ULTIMATE COLORING

THESE COLORS DON'T RUN

A COLORFUL ADVENTURE CELEBRATING AMERICA

PORTABLE PRESS

San Diego, California

Here, in *Ultimate Coloring: These Colors Don't Run*, is the best of America, for you to bring to life.You'll find a wagon that evokes the pioneers who traveled for months to reach the West. The car that changed the world. And a hot dog on four wheels that won't do anything other than put a smile on your face.

Get out your colors for the president who saved the union. And the landmarks that bear witness to American resolve. The Alamo Mission and Pearl Harbor were sites of infamous attacks, and both inspired ultimate victory. Today, in New York, One World Trade Center stands defiant in a city that called it "Freedom Tower." After catastrophe comes renewal. The world's first skyscraper rose in Chicago from the ashes of a fire. In Memphis, a people recently freed from slavery invented a new music. American singers have conquered the world, many courtesy of Capitol Records, whose offices are now a Los Angeles landmark.

As extraordinary as what we have created are the wonders of nature, from a tree thousands of years old to a geyser that predicts earthquakes, from the bighorn sheep fighting all along the Rockies to the brown bears in our national parks. The land is yours to enjoy—go hunting in the forest, or angling in the river, or drive a dogsled along trails that have been traveled for hundreds of years.

All these scenes are here for you to color as you want—just as this is a country that was built on the idea of freedom. Over the centuries, those who came from around the world have given thanks for their opportunities, and they have never shirked from a fight. Whenever it's been under attack—from within or without—Americans have always rallied to their flag. There's a reason for that saying: "These colors don't run."

OLD FAITHFUL, YELLOWSTONE NATIONAL PARK, WYOMING

It's not the tallest or even the largest geyser in Yellowstone National Park, but it is the most reliable—hence its name. Over the years, the interval between eruptions has altered, perhaps as a result of earthquakes impacting underground water levels. Earthquakes in the area surrounding the geyser can be expected within two weeks of the intervals lengthening and the eruption itself diminishing.

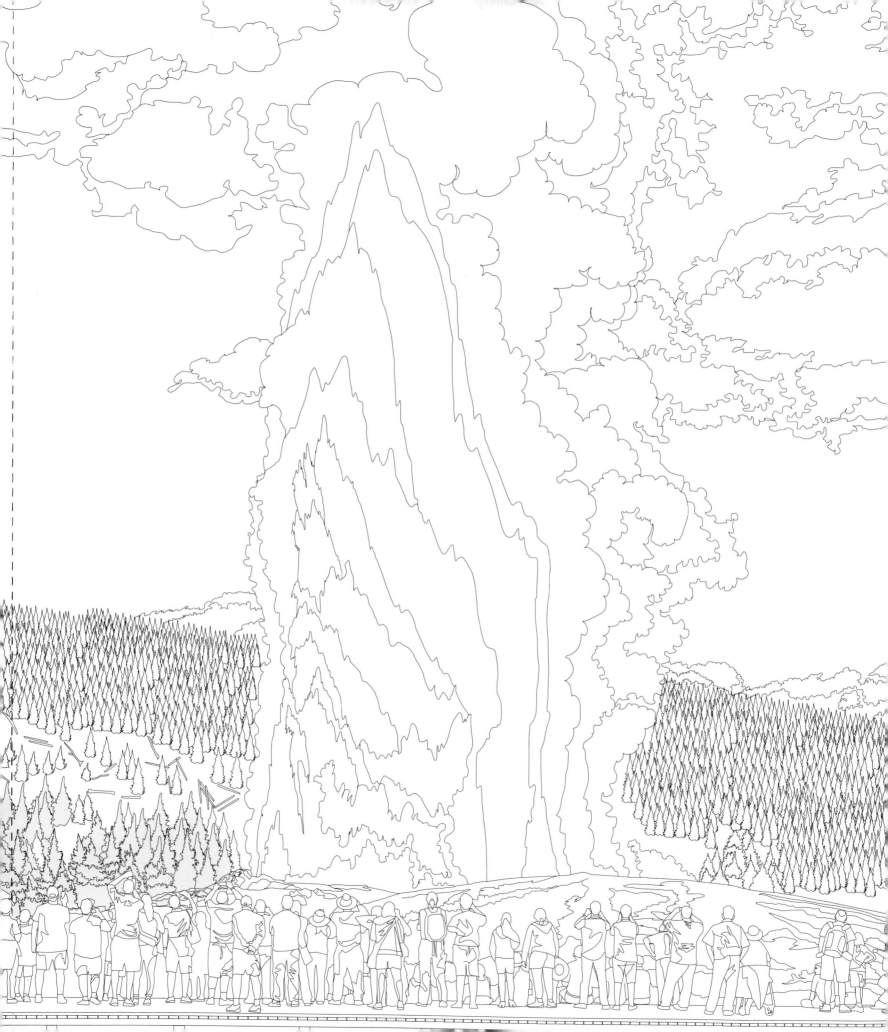

GENERAL SHERMAN TREE, SEQUOIA NATIONAL PARK, CALIFORNIA

General Sherman is a giant sequoia named by the naturalist James Wolverton, who had served under the Civil War general. Standing 275 feet tall, it's at least 2,000 years old. A branch fell off in January 2006; at 90 feet long and with a diameter of more than 6 feet, the branch was larger than many trees.

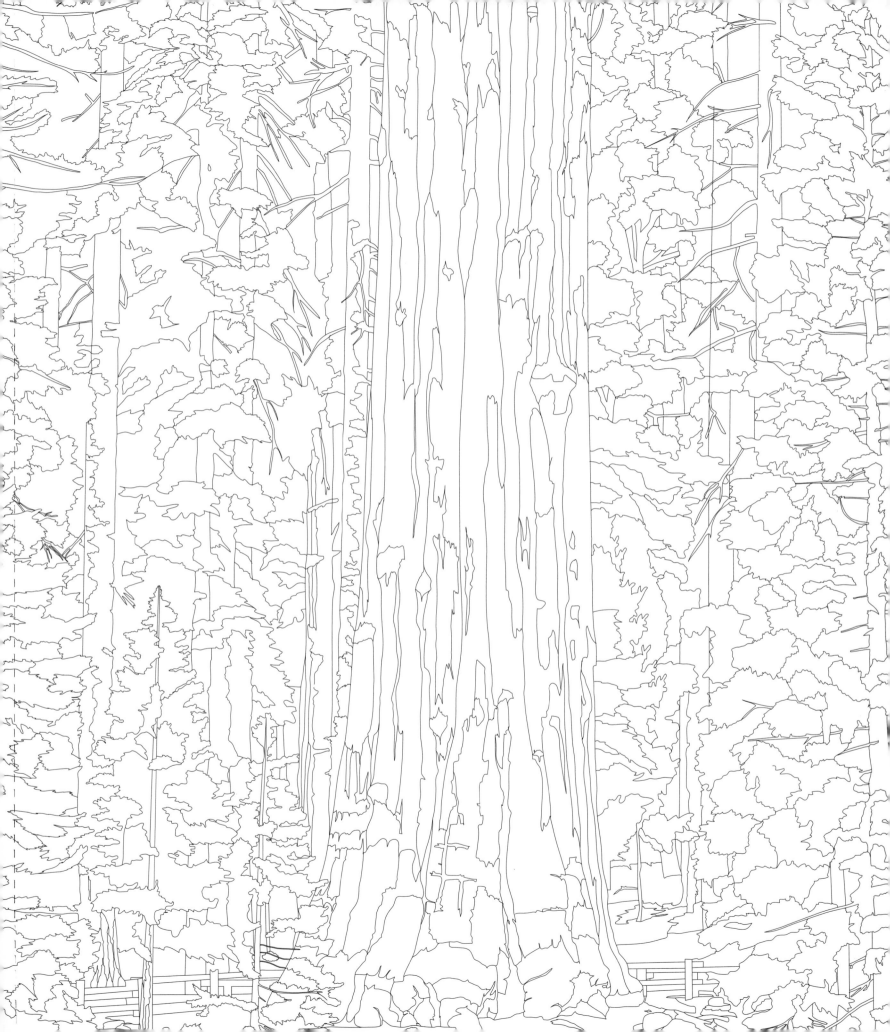

USS *ARIZONA* MEMORIAL, PEARL HARBOR, HAWAII

Straddling the hull of the USS *Arizona*, the memorial honors those killed on December 7, 1941. Peaks at either end, with a center that sags, are integral to the design: confidence was dented by the Japanese attack, but America had risen to new heights by the war's end. The memorial, which opened in 1962, receives around 1.5 million visitors each year.

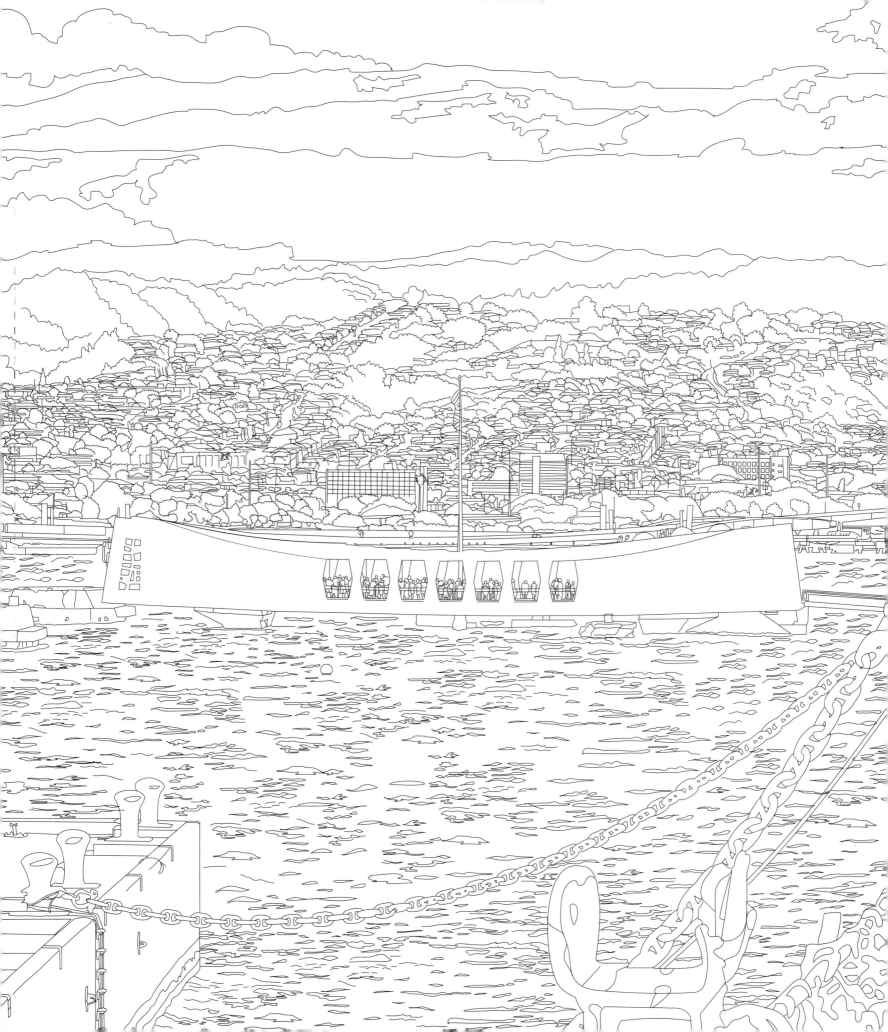

KENTUCKY DERBY, LOUISVILLE, KENTUCKY

They call it "the Most Exciting Two Minutes in Sports"—with good reason. The Kentucky Derby has been running continuously since 1875, and is the first leg of horse racing's Triple Crown. Held on the first Saturday in May, the Kentucky Derby is the premier horse racing event in the country.

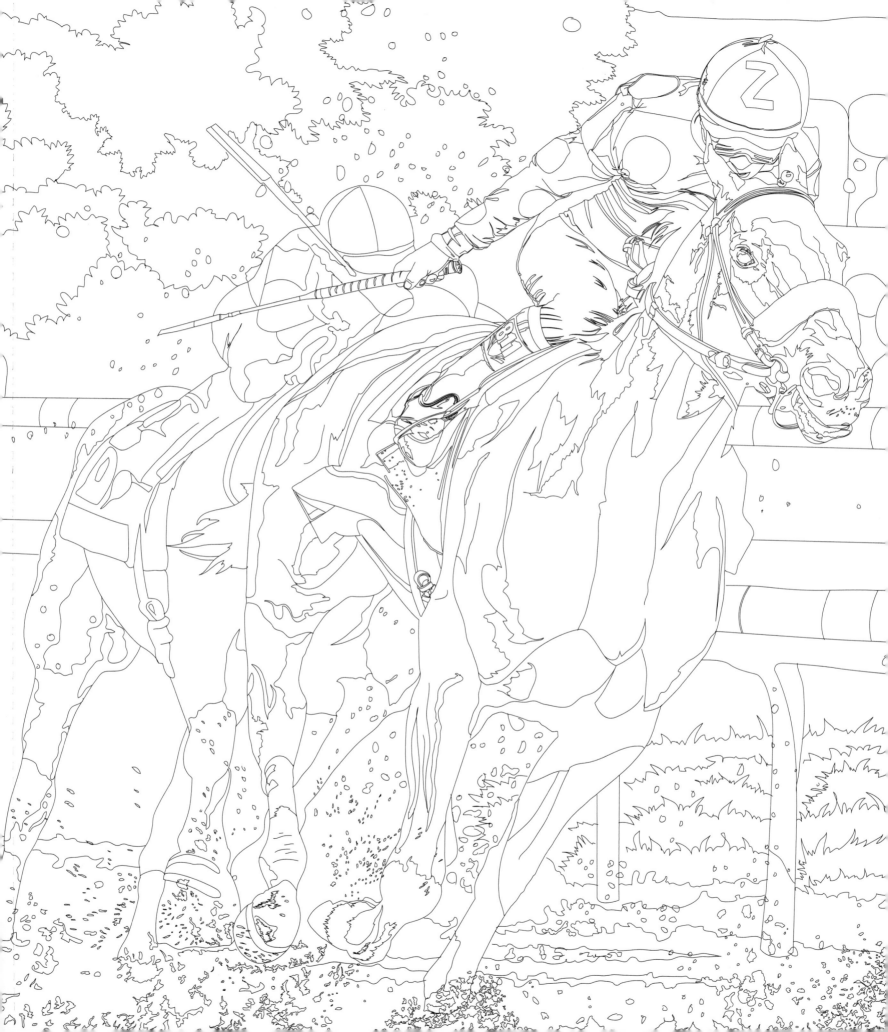

PAUL BUNYAN AND BABE THE BLUE OX, KLAMATH, CALIFORNIA

You'll find statues of the legendary lumberjack in several American states. At the entrance to the Trees of Mystery in Klamath, California, the statue of Bunyan is 49 feet tall. Beside him stands Babe, the ox that seemingly never recovered from the Winter of the Blue Snow. The Babe statue used to blow smoke from its nostrils—until too many kids got scared. Heavy rain was a challenge in 2007, and Babe's head fell off. It has now been replaced.

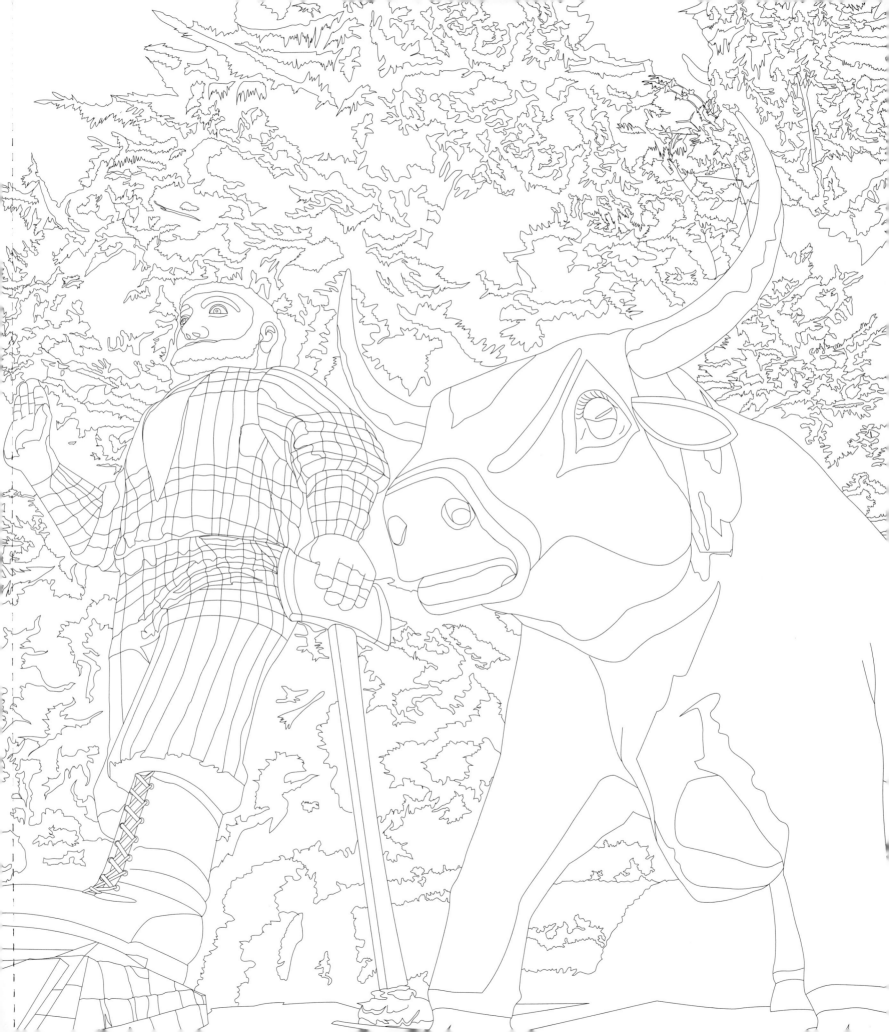

VANDERBILT MANSION, HYDE PARK, NEW YORK

It has fifty-four rooms, but the Vanderbilt Mansion was used by the family only for vacations. Originally set within a 600-acre estate, it was conveniently close to New York—particularly when traveling by the New York Central Railroad (owned by Frederick W. Vanderbilt). It is now listed on the National Register of Historic Places.

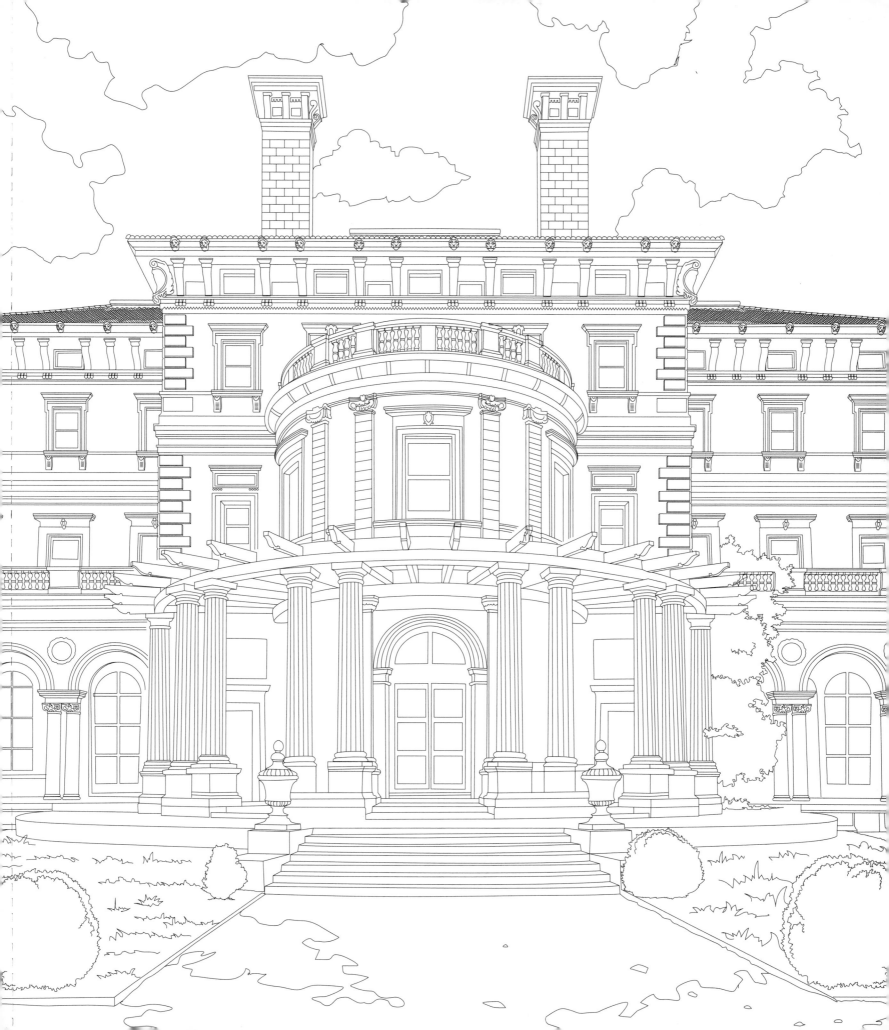

CAPITOL RECORDS BUILDING, LOS ANGELES

It's round like a stack of records, and the 90-foot spire recalls the needle on a record player. But apparently it's a coincidence that this is the home of Capitol Records: The world's first circular office building was based on designs created by the architect while still at graduate school. Artists from Frank Sinatra to Nat King Cole have recorded here in the studios based on the ground floor.

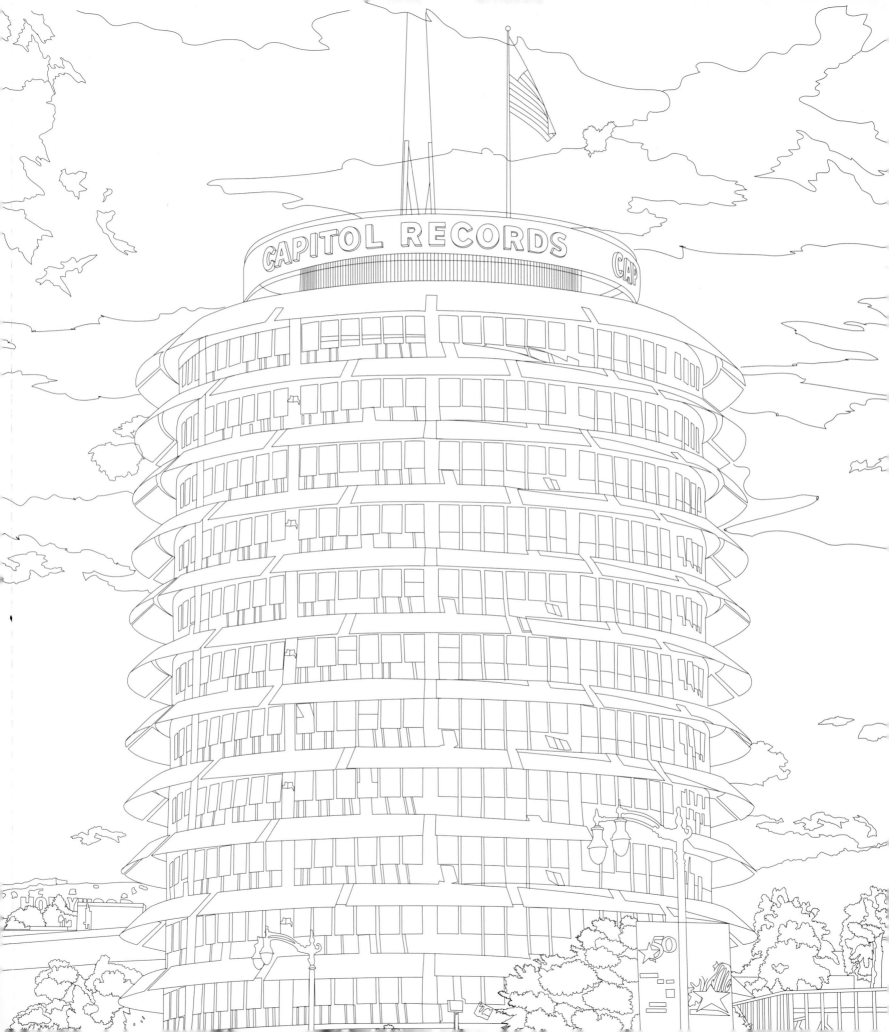

IDITAROD TRAIL, ALASKA

The Iditarod Trail is at least 1,000 miles long, a distance that changes from year to year according to the conditions—even, as in 2015, a lack of snow! Usually, though, mushers and their dogs can expect to race in blizzards and subzero temperatures. They pass through forests, over hills, and across rivers on a route that has been traveled for centuries by Native Americans.

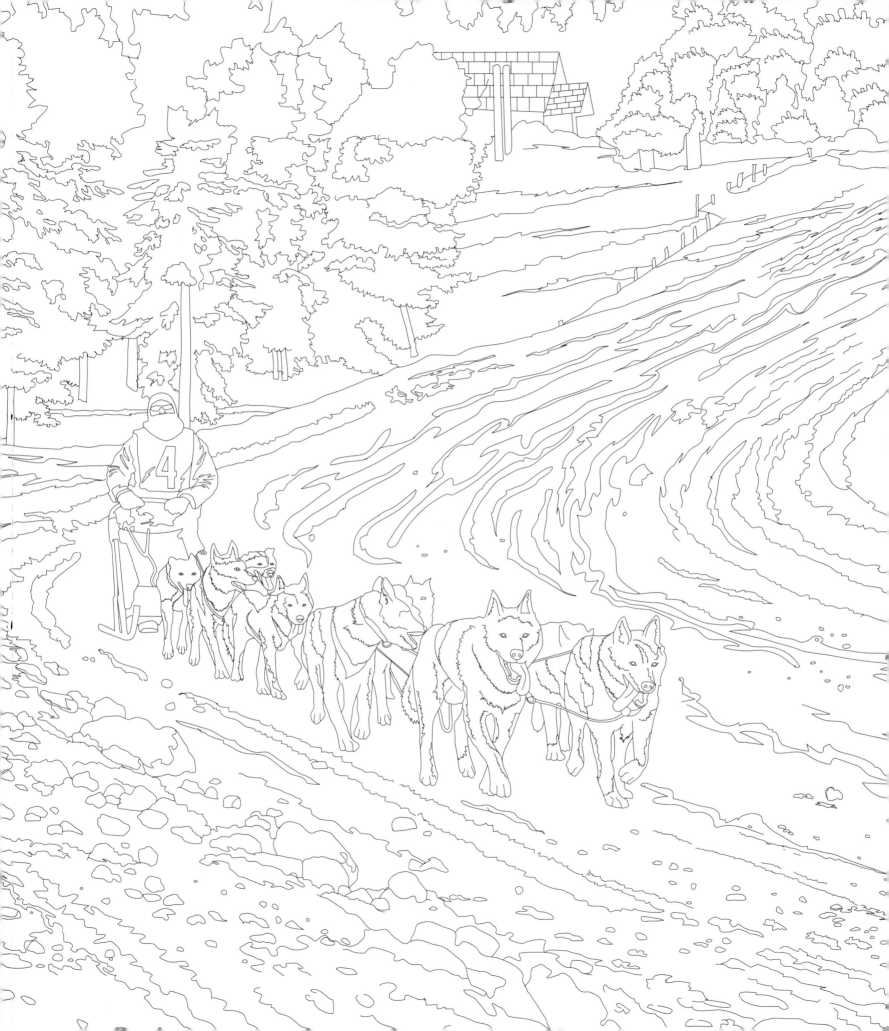

SOUTH STREET SEAPORT, NEW YORK CITY

People have been trading out of the South Street Seaport for nearly 400 years. The first pier was built here in 1625. In the next century, trade links were established with the Carolinas and England—interrupted only by the Revolutionary War. Then, just a year after independence, trade began with China. A regular trans-Atlantic route to England was established in 1818, and New York soon developed into a center of world trade.

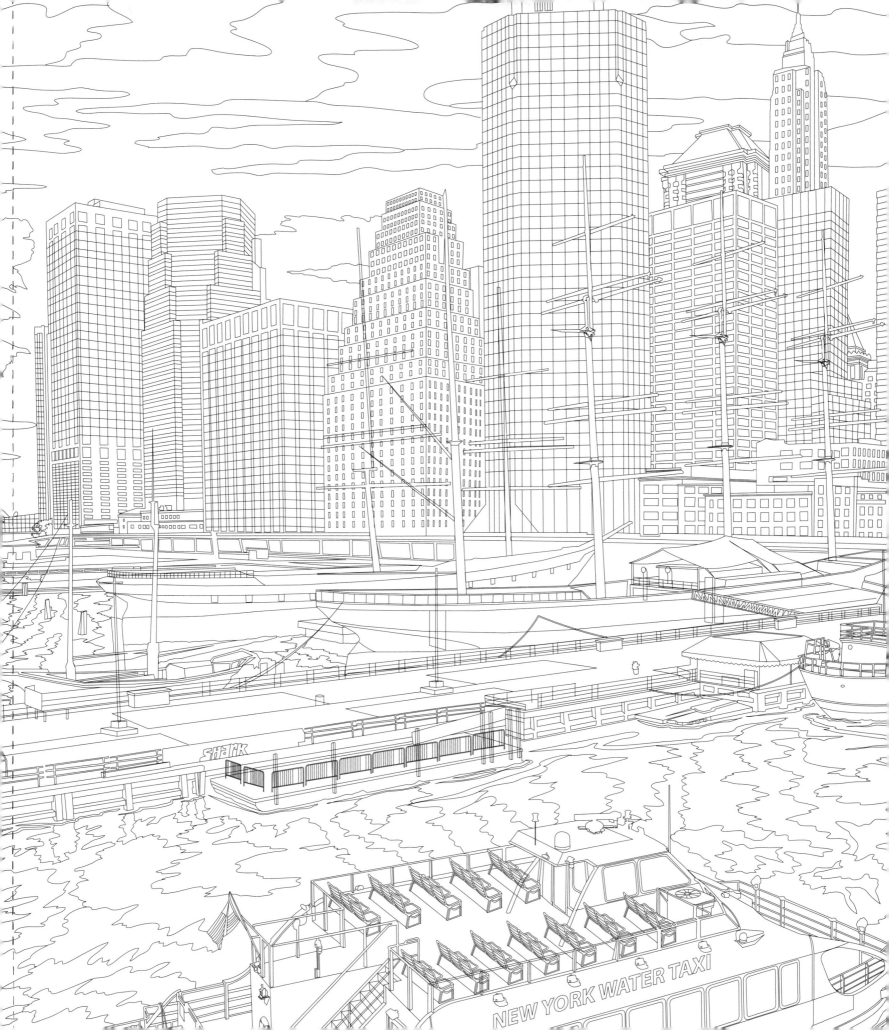

THANKSGIVING TABLE

We all expect a turkey at the center, but the modern Thanksgiving table also embraces food traditions from across the world. You may be served lefse, a flatbread from Scandinavia, or sauerkraut from Germany and eastern Europe. Mofongo, a stuffing made from plantains, has its origins in Africa. A kugel for dessert will likely mean you're dining with Ashkenazi Jews, and the heritage of South America has created a crème caramel made with pumpkin.

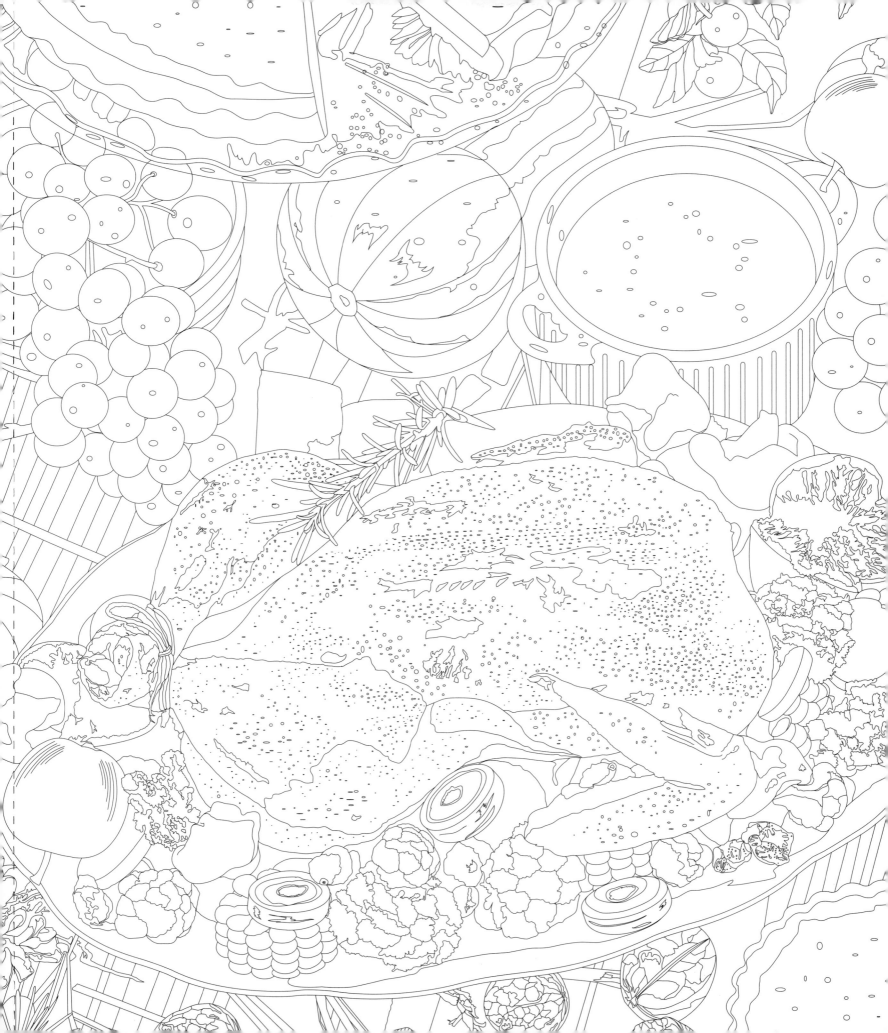

GRAYSON HIGHLANDS STATE PARK, VIRGINIA

Established in 1965, this state park was created after the local community raised funds to buy the land. The area had first been settled in the late 1800s by families who made their living from the land. They boiled cane juice to make molasses, and made apple butter to get through the winter, slow cooking the apples in a copper kettle over an open fire.

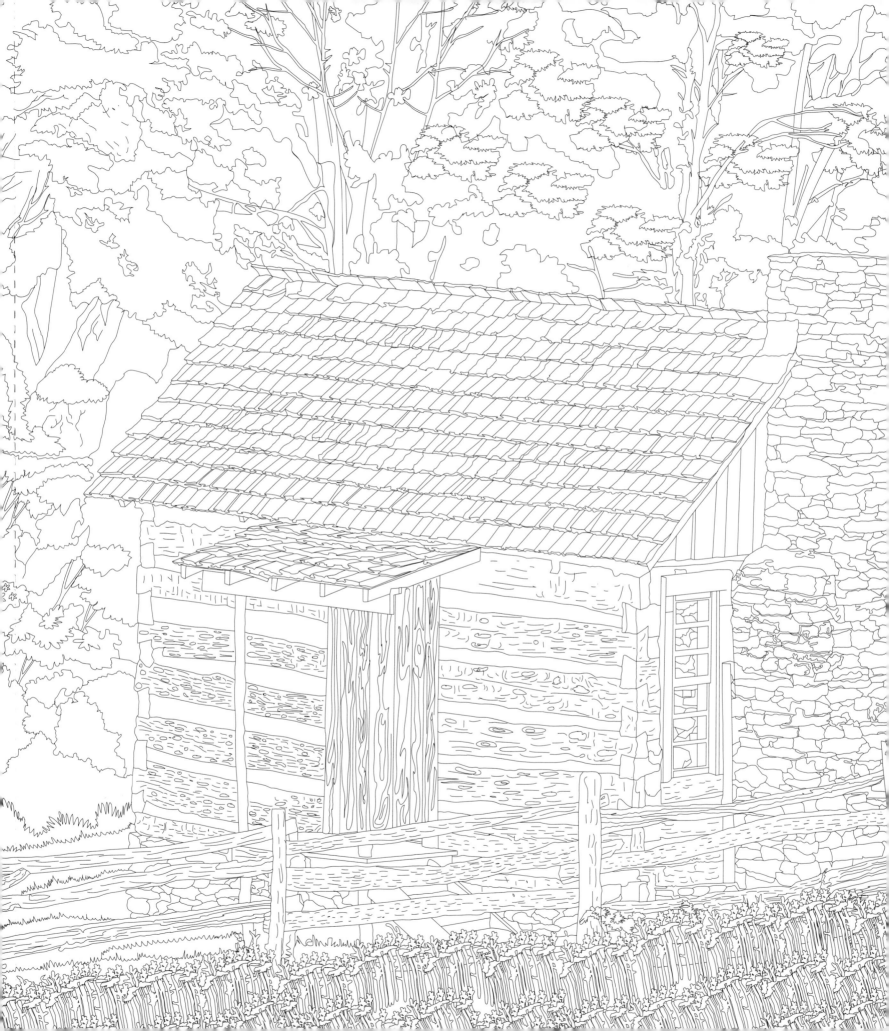

CARHENGE,
ALLIANCE, NEBRASKA

Yes, this is a replica of Stonehenge in England—and yes, it's built from cars. Thirty-nine vintage American cars, in fact, all of them spray-painted gray. The man behind it is Jim Reinders, who created this memorial for his father with the help of his family. "It took a lot of work, sweat, and beers," he says, but the monument was completed in a month, ready for the summer solstice in June 1987.

MONTEREY PENINSULA SHORE COURSE, PEBBLE BEACH, CALIFORNIA

There are eight golf courses at Pebble Beach—a dramatic coastline that looks out across the Pacific Ocean. The Shore Course is part of the PGA Tour, and has become a favorite. No wonder: players share the course with deer and bobcats, and may also see whales and dolphins. Then there's the excitement of the course itself: imagine teeing off toward a green that stands alone on a rocky peninsula.

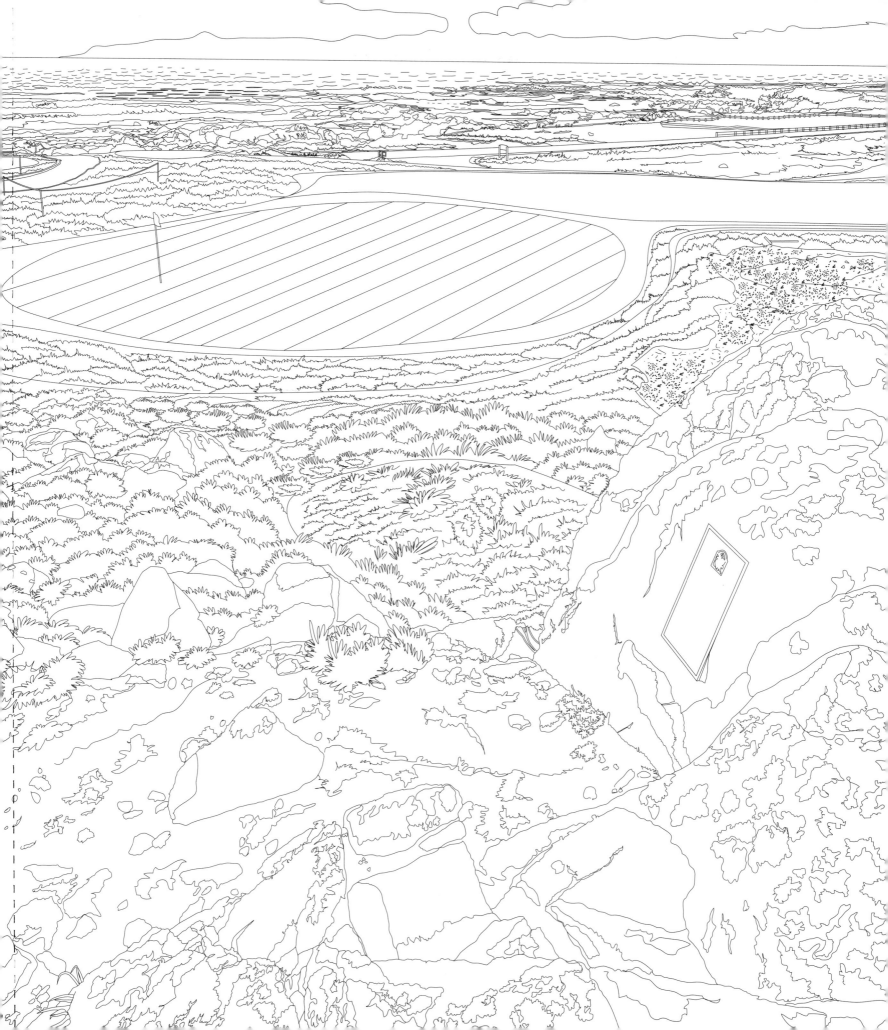

FARM TRACTOR

In 1892 John Froelich built a machine that was powered by gasoline and which had both forward and reverse gears. He didn't call it a tractor, but this was the prototype for the machine that revolutionized farming in the twentieth century. By saving time and money, it increased production, and the innovations continue. GPS devices and onboard computers allow some modern tractors to be operated without a driver.

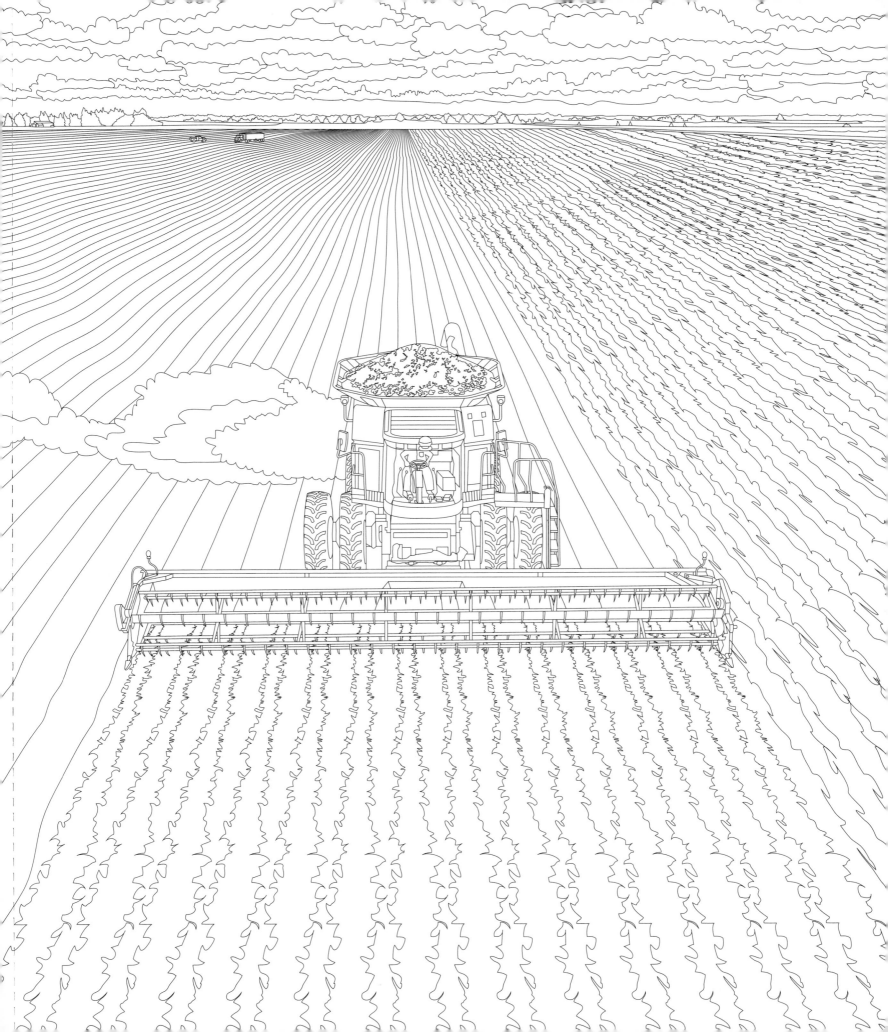

DURANGO AND SILVERTON NARROW GAUGE RAILROAD, COLORADO

Steam locomotives have been carrying passengers and freight on this narrow gauge railroad since 1882. It was built to transport silver and gold ore, and after mining went into decline, the line might have fallen into disuse. That's where Hollywood entered the story: a number of movies were shot along the line in the 1940s, and visitors came to experience what they had seen in the theater.

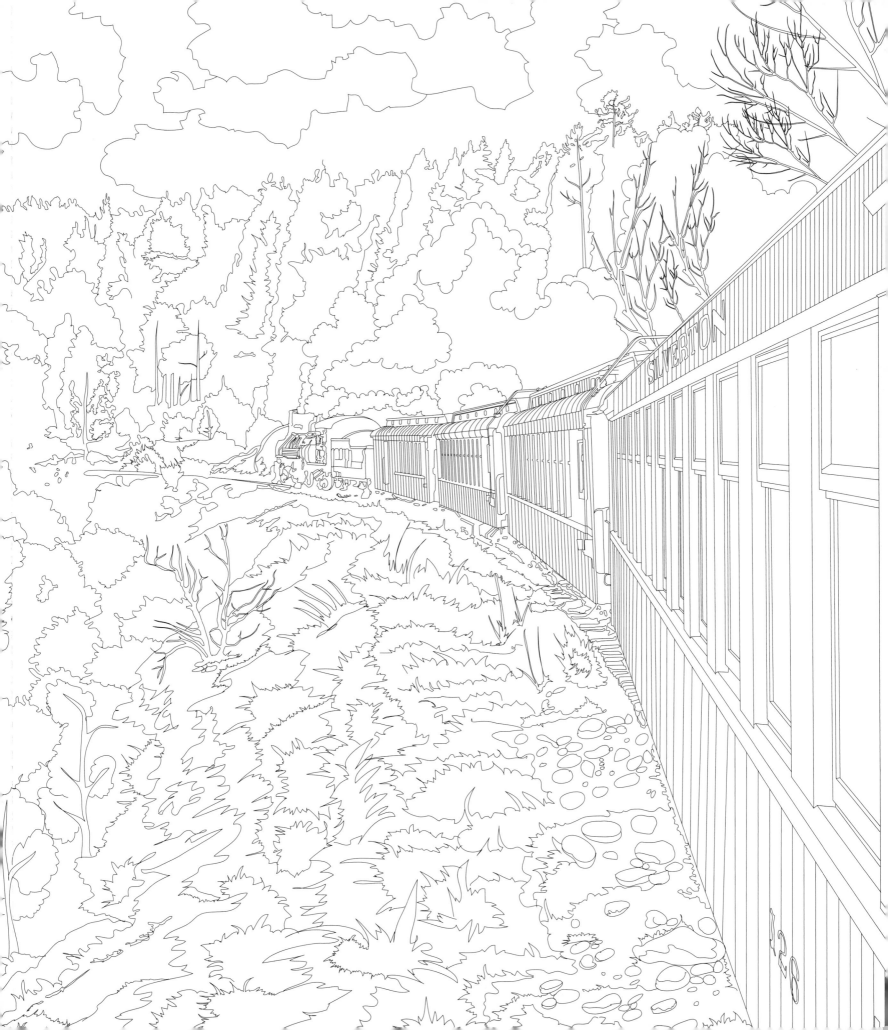

COVERED WAGON

It's an icon of the American West, but the pioneers who crossed the country avoided traveling in covered wagons if they could. Without suspension, these were an uncomfortable ride even over good ground. So wagons carried the young, the old, and the infirm—everyone else walked. Hundreds of thousands set out on the trail, crossing plains, mountains, even deserts on journeys that took several months.

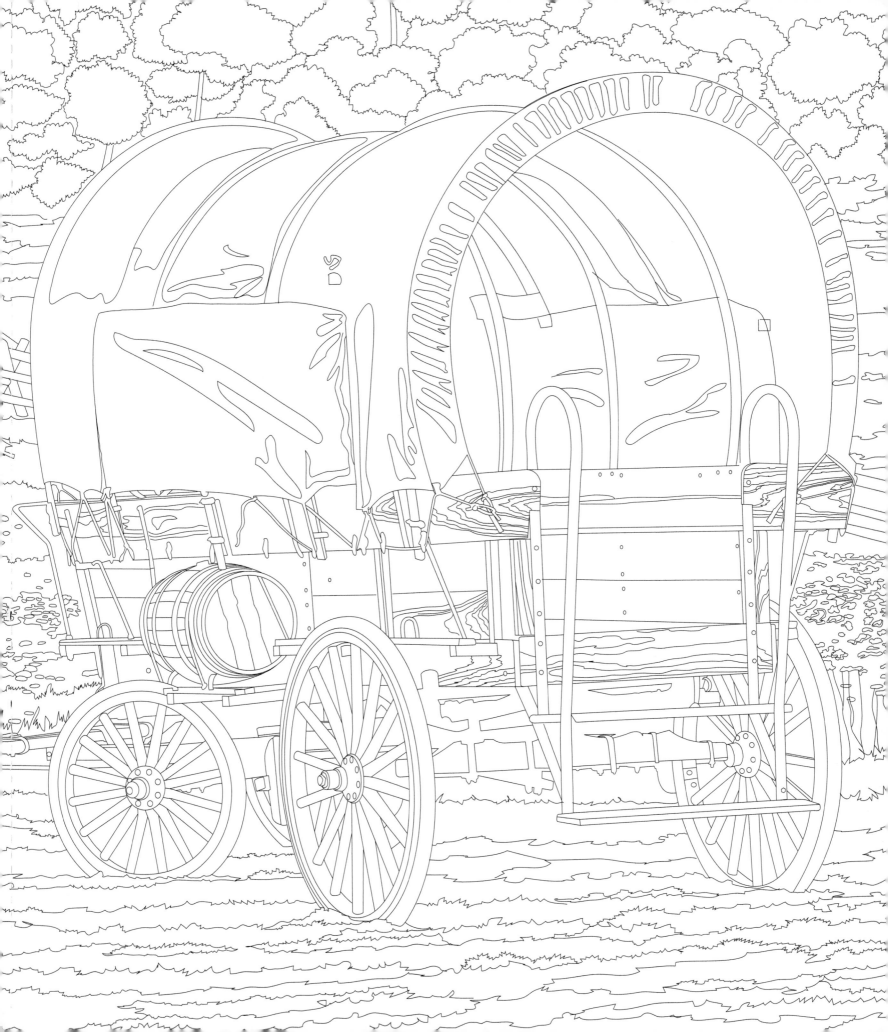

BIGHORN SHEEP

The large curved horns that give the sheep its name can weigh up to 30 pounds—more than the combined weight of every other bone in the ram's body. Two rams competing for dominance may fight for hours, hurling themselves at each other at speeds of up to 20 miles per hour. The sound of their combat can be heard up to a mile away.

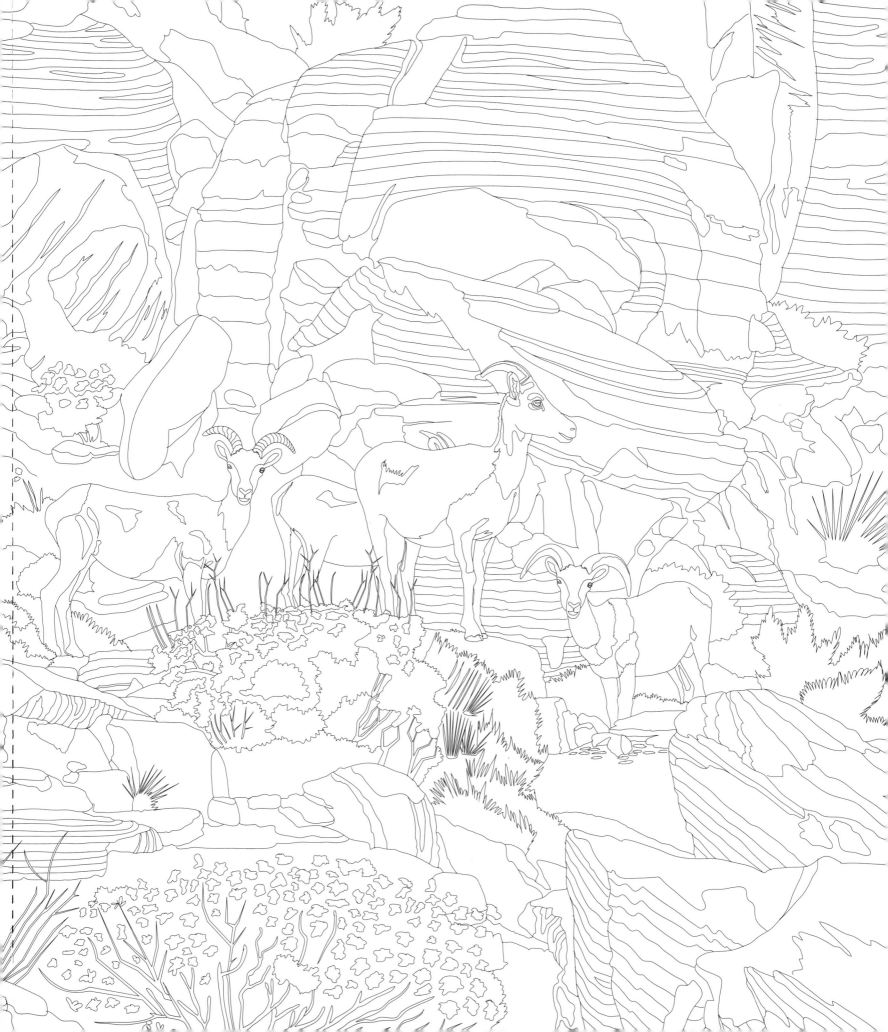

SAILBOAT

Humans have been sailing for thousands of years—but it was the Dutch who first invented the idea of sailing as a sport. A yacht given to Charles II, king of England, introduced the sport to that country, and from there it spread to what were then the American colonies. The New York Yacht Club was the first in the United States, and was initially headquartered at Hoboken, New Jersey.

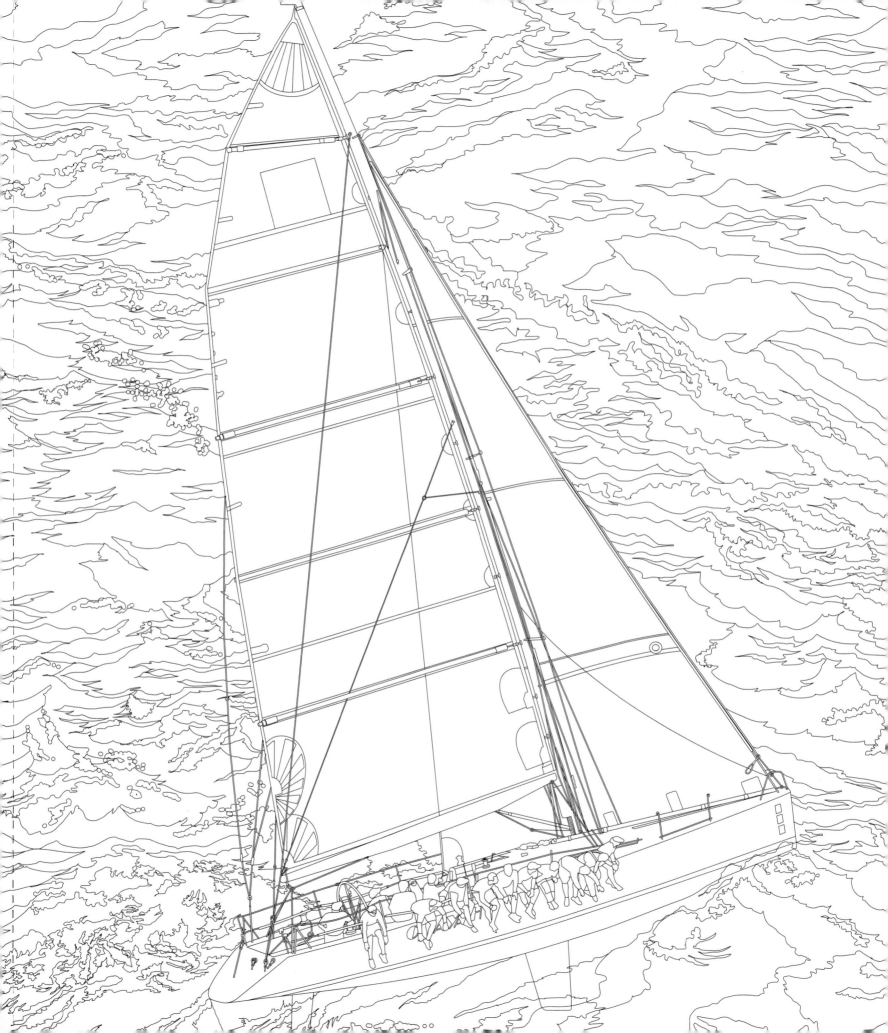

MOUNTAIN LION

Whatever you call it—mountain lion, cougar, panther, puma, or catamount—it's the second-largest wild cat in North America. Don't expect to hear it roar, though. It can only manage a purr. A skilled hunter, the mountain lion will hide before pouncing with its claws outstretched, leaping up to 20 feet to stun prey such as deer, raccoons, and other small mammals.

BOWLING ALLEY

We have Connecticut to thank for tenpin bowling. The alleys for the popular game of ninepin bowling were too closely associated with gambling and crime—and in 1841 they were banned. Adding an extra pin seemed a good way around the law—or so the story goes. However, the International Bowling Hall of Fame has a picture of a game played with ten pins, dating from around 1810.

KENNEDY SPACE CENTER, FLORIDA

The Kennedy Space Center was established in 1963, and has served as NASA's main launch center since 1968. The visitor center houses a restored Saturn V rocket, as well as other exhibits relating to the U.S. space program. Approximately 1.5 million visitors tour the complex each year.

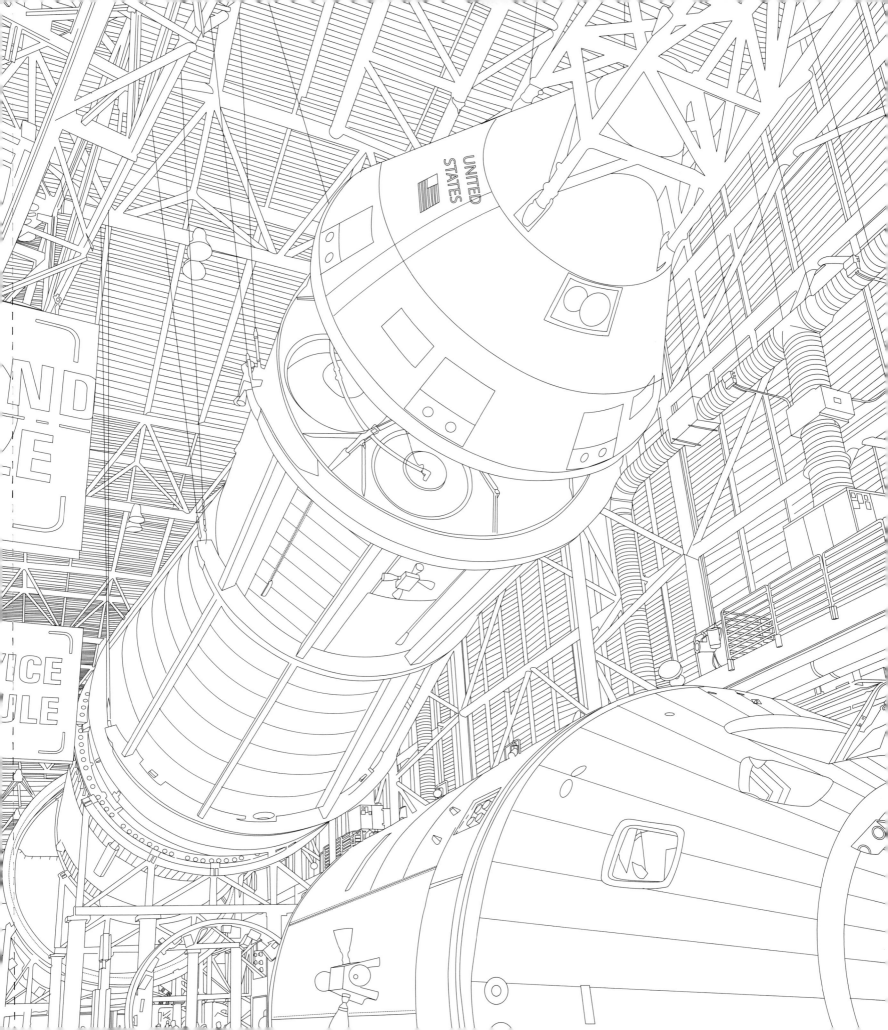

LINCOLN MEMORIAL,
WASHINGTON, D.C.

From the time of his assassination in 1865, there were calls for a national memorial to Abraham Lincoln. Plans were even drawn up—but the funds could not be raised. Not until the start of the twentieth century were the calls renewed, and only in 1910 did a bill pass through Congress, after five earlier ones had failed.

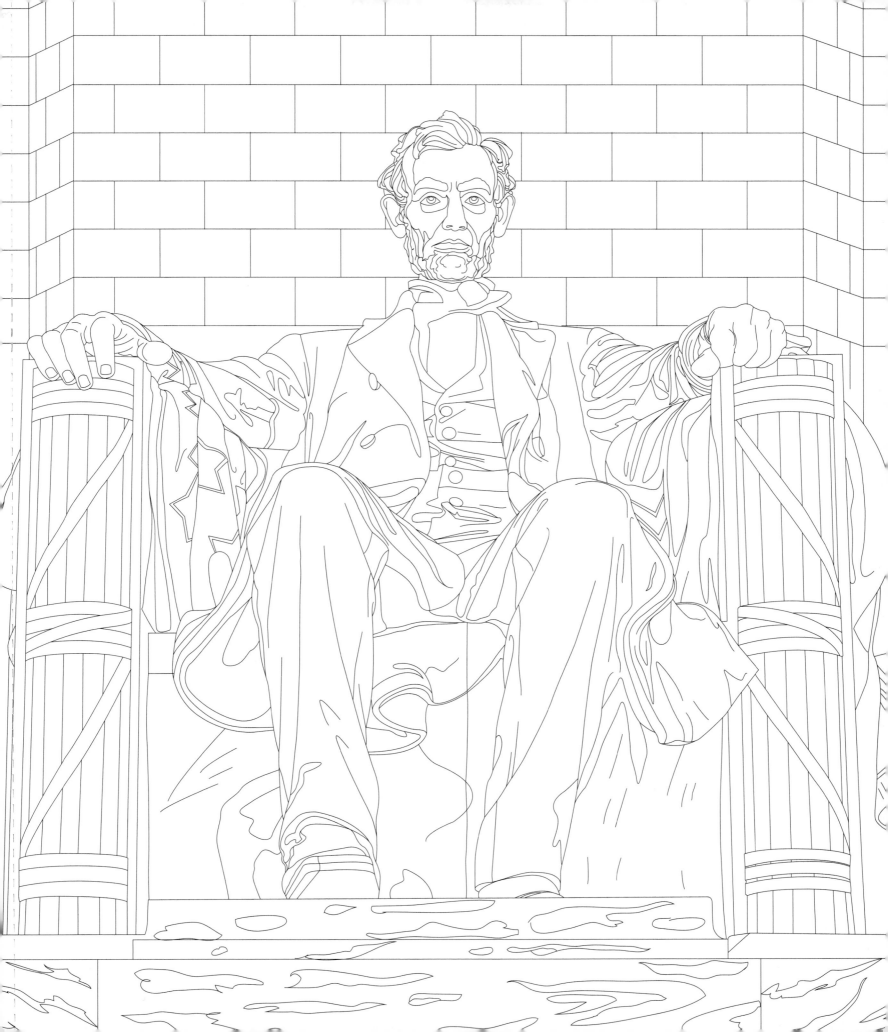

BROWN BEARS

In Katmai National Park, Alaska, you'll find more bears than in any other national park in the world—more than 2,000. They hibernate for up to seven months each year, and in the spring, you'll see them on the mudflats, digging for clams. By later summer and fall, the rivers are flush with sockeye salmon, and each bear tries to reserve its favorite fishing spot.

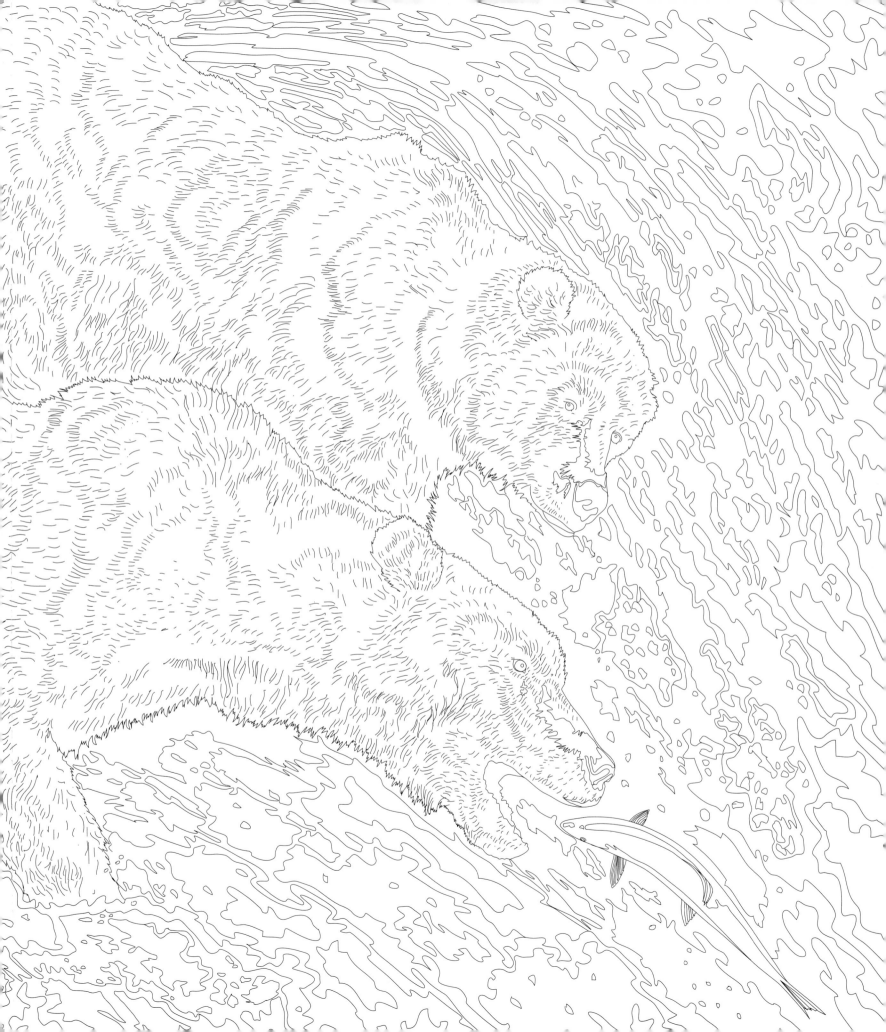

MONSTER TRUCKS

Bob Chandler wasn't a man with a plan, but he had his own truck and he liked improving it. A bigger axle, a bigger engine, bigger tires, and so on. Before long, he had created Bigfoot, the world's first monster truck. In 1981 he drove it over a couple of old cars, and the event was captured on film. A sports promoter saw it—and now there are monster truck shows across the country.

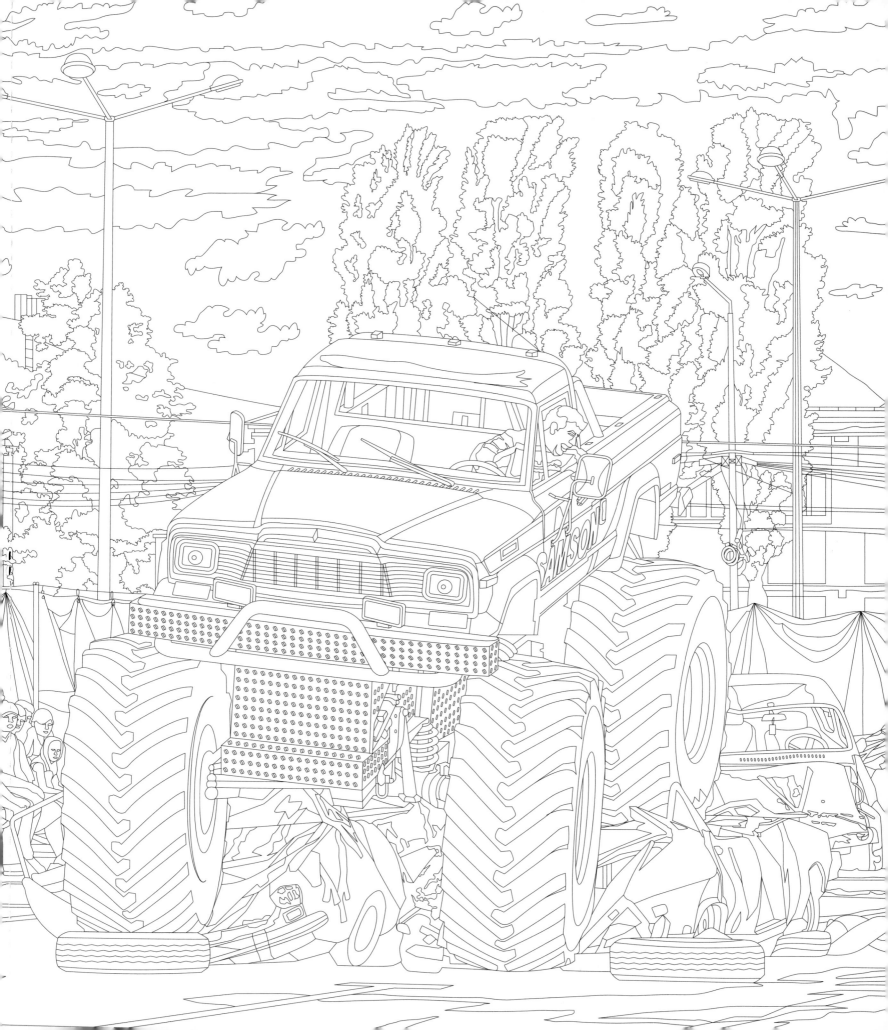

DINER

Look around a diner, and what you usually see is a prefabricated design that reflects the American melting pot. Italian designers contributed the checkerboard floor, that chrome counter was the work of German sheet metal workers, and the booths came courtesy of French-Canadian carpenters. The large windows seen in so many diners were a later development, an attempt to catch the attention of passing motorists—numbers of which boomed after World War II.

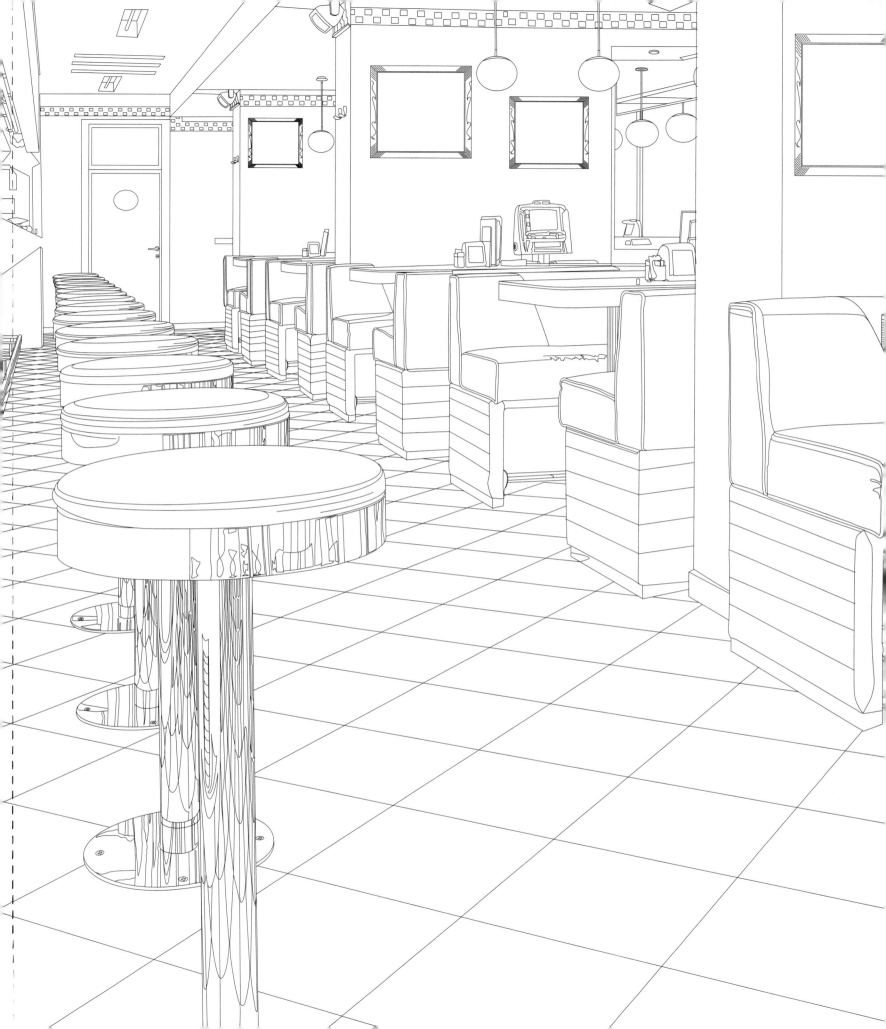

B-17 FLYING FORTRESS: *MEMPHIS BELLE*

The *Memphis Belle* was only the second heavy bomber to complete 25 combat missions in the European Theater, with the loss of no crew. More remarkable still is that all the missions were part of daylight raids—during which the plane dropped more than 60 tons of bombs. On the completion of the final mission, the crew returned to the United States and joined a publicity campaign to sell war bonds.

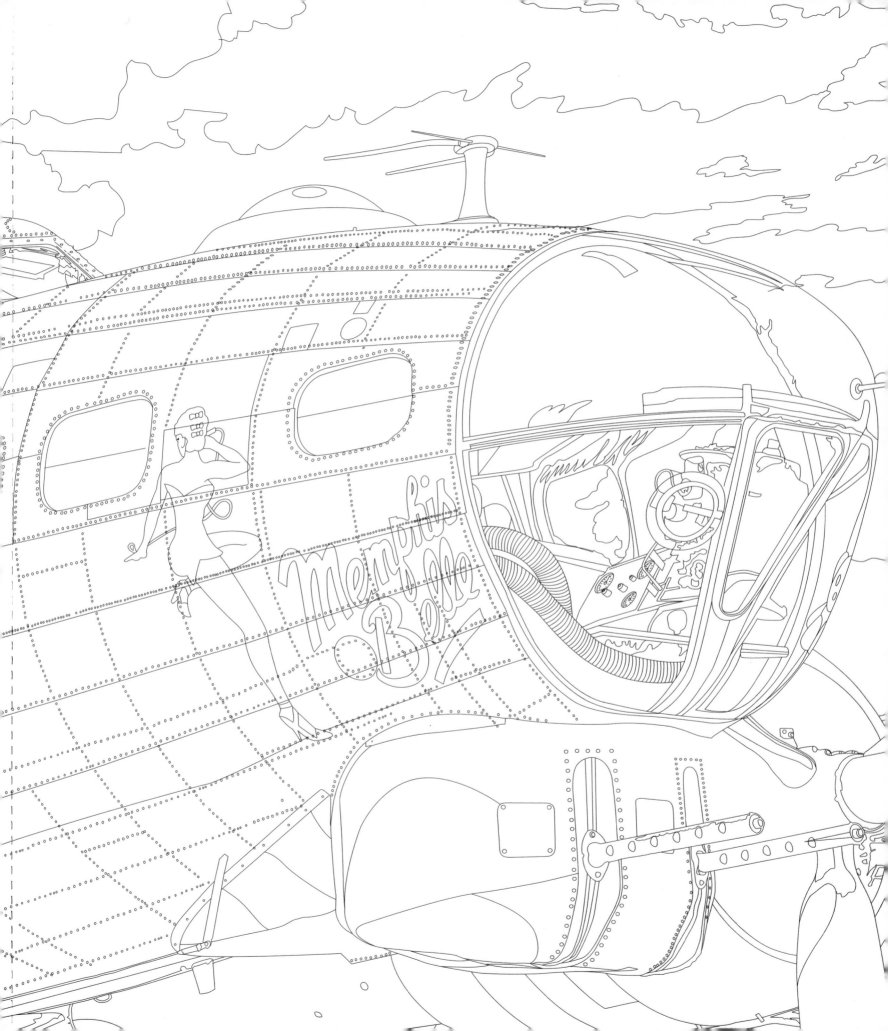

MONUMENT VALLEY, UTAH

Monument Valley is a landscape millions of years in the making. It once lay in a basin, and the lowest levels of sandstone were formed from sediment carried here by rivers from what are now the Rocky Mountains. Above sits a layer of sandstone that was blown here by the wind—much as dunes form in deserts today.

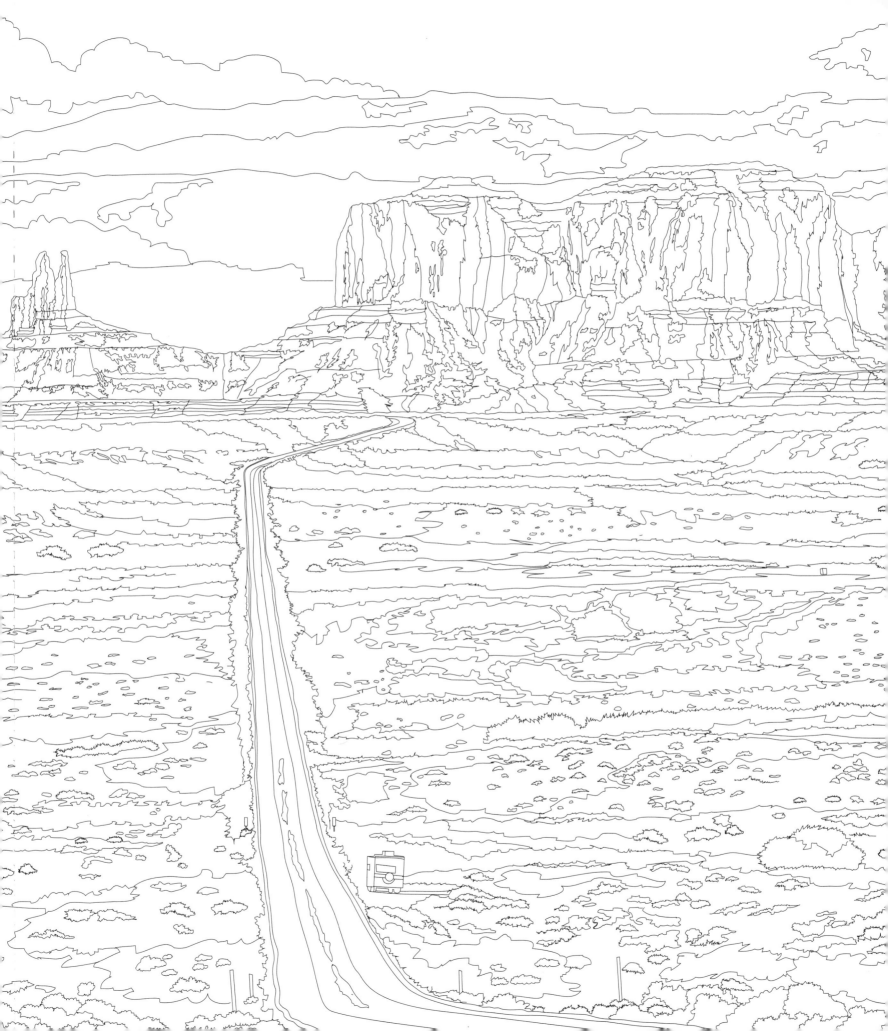

BIG RIG

Take a tractor unit and a semitrailer, then put them together and you have a big rig. Exact specifications vary depending on the cargo it will carry, but you won't need a license for loads up to 80,000 pounds. The brakes on these eighteen-wheelers are controlled by air pressure rather than hydraulic fluid, which can overheat or leak. It's a fail-safe design, and if the brakes stop working, the truck comes to a halt.

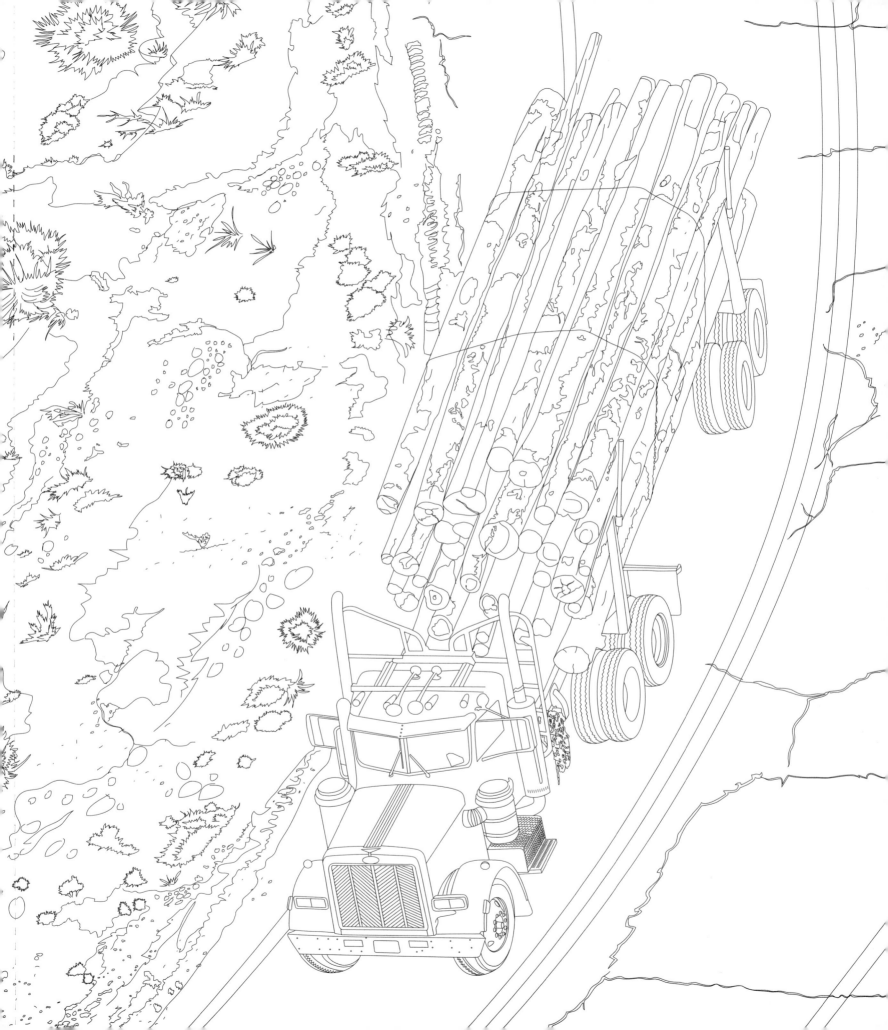

ROLLING THUNDER RUN TO THE WALL, WASHINGTON, D.C.

Rolling Thunder is an organization that came out of the Vietnam War. Its purpose is to focus attention on prisoners of war and those missing in action. Ray Manzo, a former Marine, suggested a motorcycle rally through Washington, D.C., from the Pentagon, across the Memorial Bridge, to the Vietnam Veterans Memorial Wall.

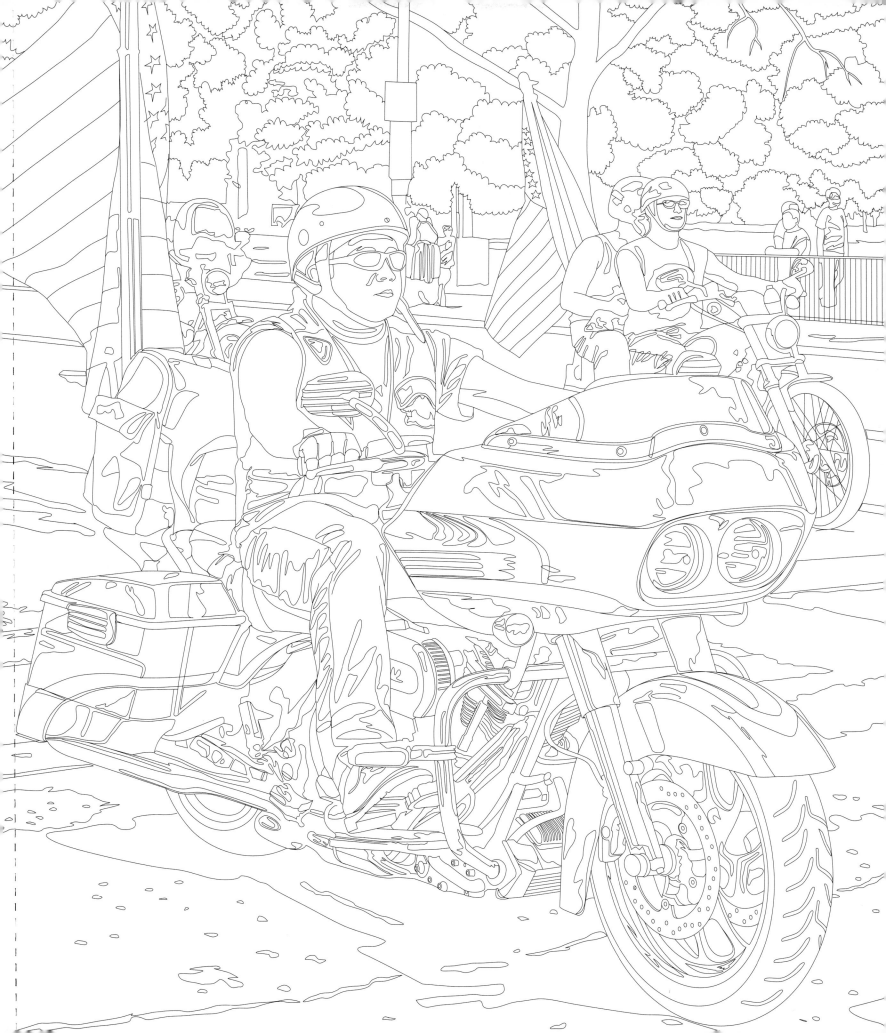

ALAMO MISSION, SAN ANTONIO, TEXAS

Sometimes winning the battle is the reason for losing a war. When Mexican troops attacked the Alamo Mission, they left not one single defender alive. Such cruelty proved an effective recruiting tool. Settlers not just from Texas but from across the United States flocked to join the Texian Army. Just over six weeks later, the Mexican army was defeated—and the Texas Revolution was over.

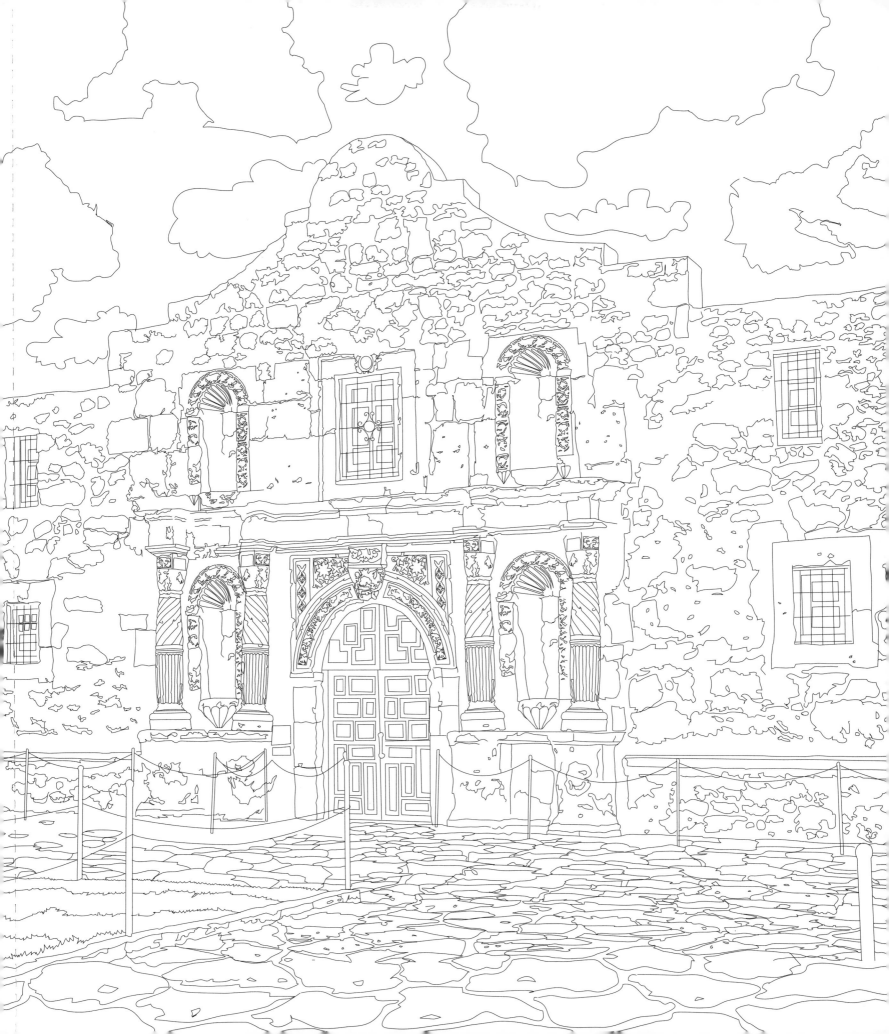

HUNTING IN THE FOREST

Go hunting in a national forest, and you must follow the rules. That means wearing fluorescent orange—including a cap. Why orange? Well, wear white or tan during deer season and chances are another hunter will think you're prey. There are exceptions: you don't have to wear orange at night or when hunting "fur-bearing animals." (That seems sensible enough: hunt bears too often, and they'll hide out during the day.)

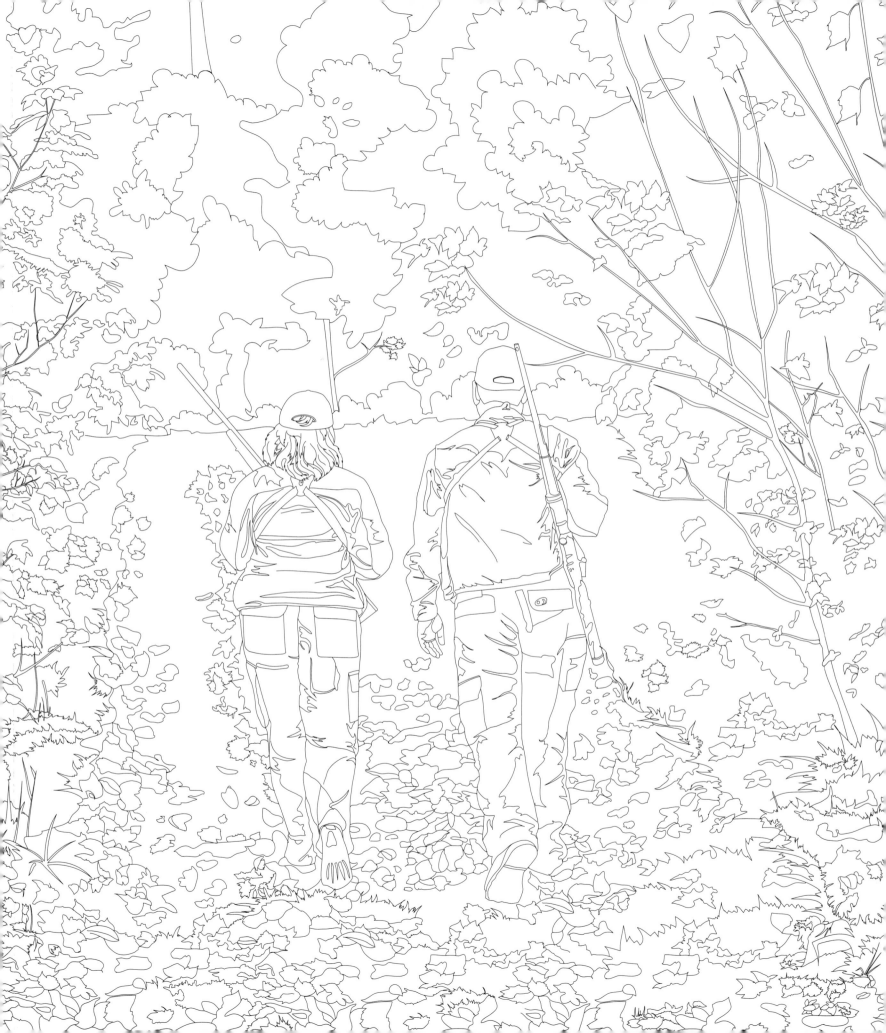

FLY FISHING

When anglers in America first used flies, they were looking to catch bass.
It didn't take them long to notice that the lures could also help them
catch salmon and trout. After all, this is a continent that offers some of
the best fishing in the world—in both rivers and lakes, though tactics and
equipment will often differ.

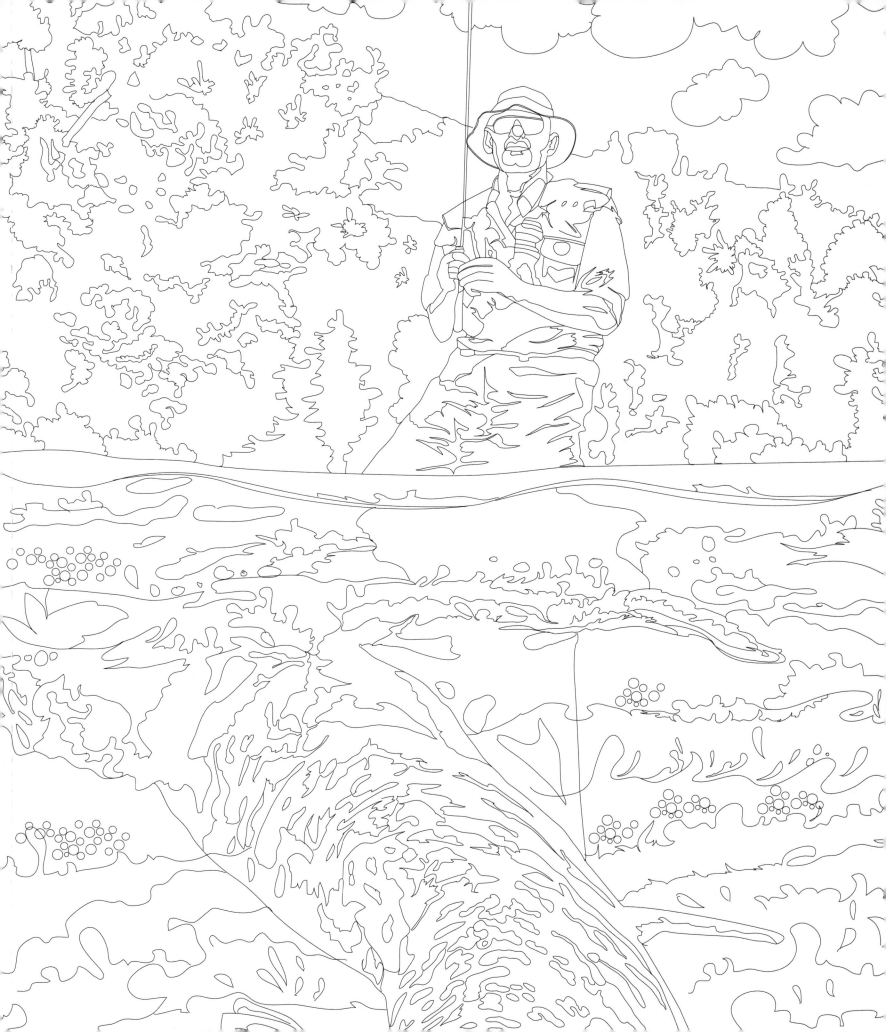

NASCAR SPRINT CUP SERIES

The NASCAR Sprint Cup is a unique challenge. Races are not conducted on identical tracks, which means that average speeds vary. Expect to see cars traveling at 188 mph at the Talladega Superspeedway, and less than half that at Sonoma Raceway (just 81 mph). The season opens with the Daytona 500—the most widely viewed auto racing event on television.

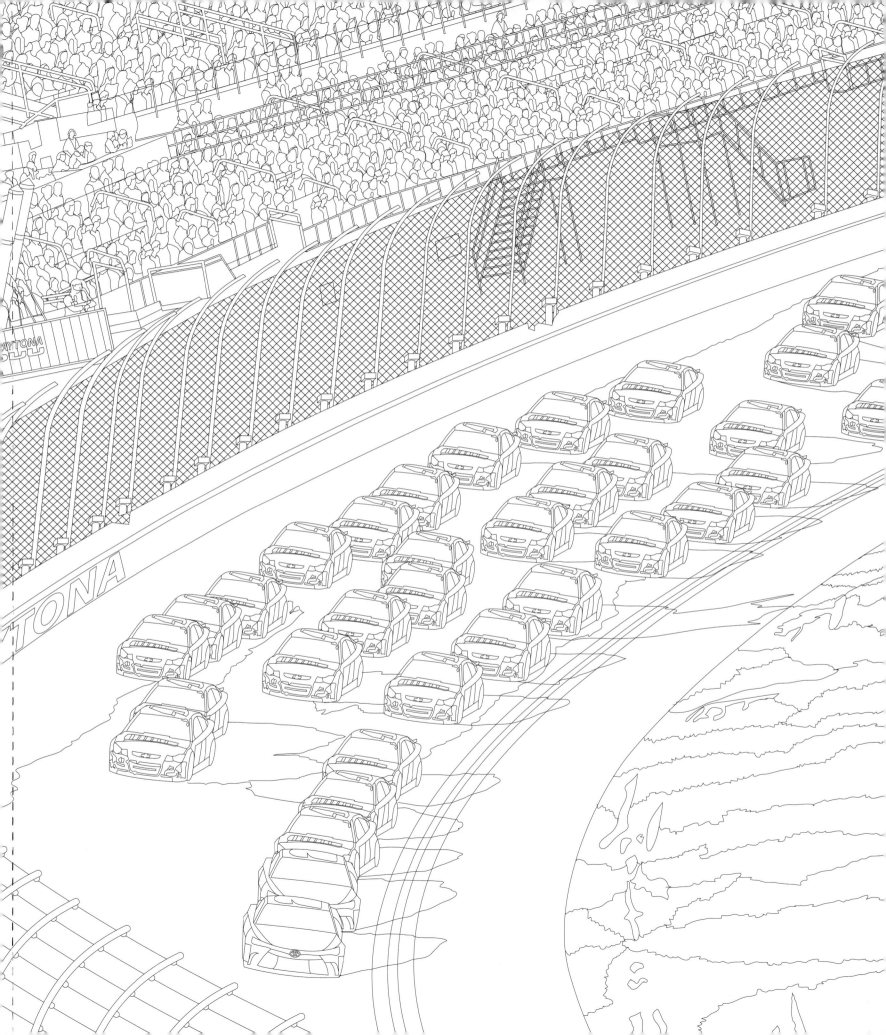

FIRE DEPARTMENT
OF THE CITY OF NEW YORK

The Fire Department of the City of New York (FDNY) is the largest fire department in the United States. Protecting more than 8 million residents, the FDNY faces unique challenges, as it is responsible for responding to emergencies at single-family homes, high-rises, subways, parks, and on the water. The FDNY is also known as "New York's Bravest."

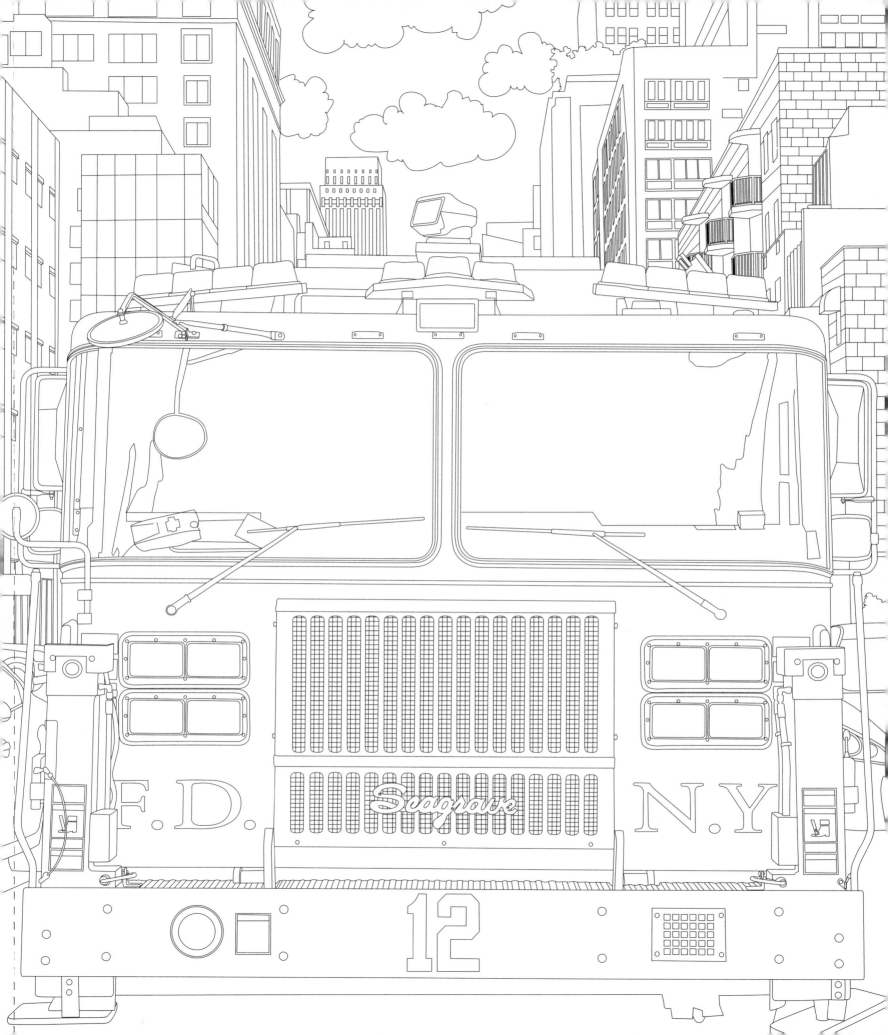

PENTAGON,
WASHINGTON, D.C.

In May 1941, the War Department needed additional office space. But as war approached, the need to preserve steel meant that any new building could be no more than four stories high. That's why the building sprawls outward. As for its distinctive shape, that echoes the shape of its original site at nearby Arlington Farms. President Franklin D. Roosevelt liked it, too—so when the site changed, the design didn't.

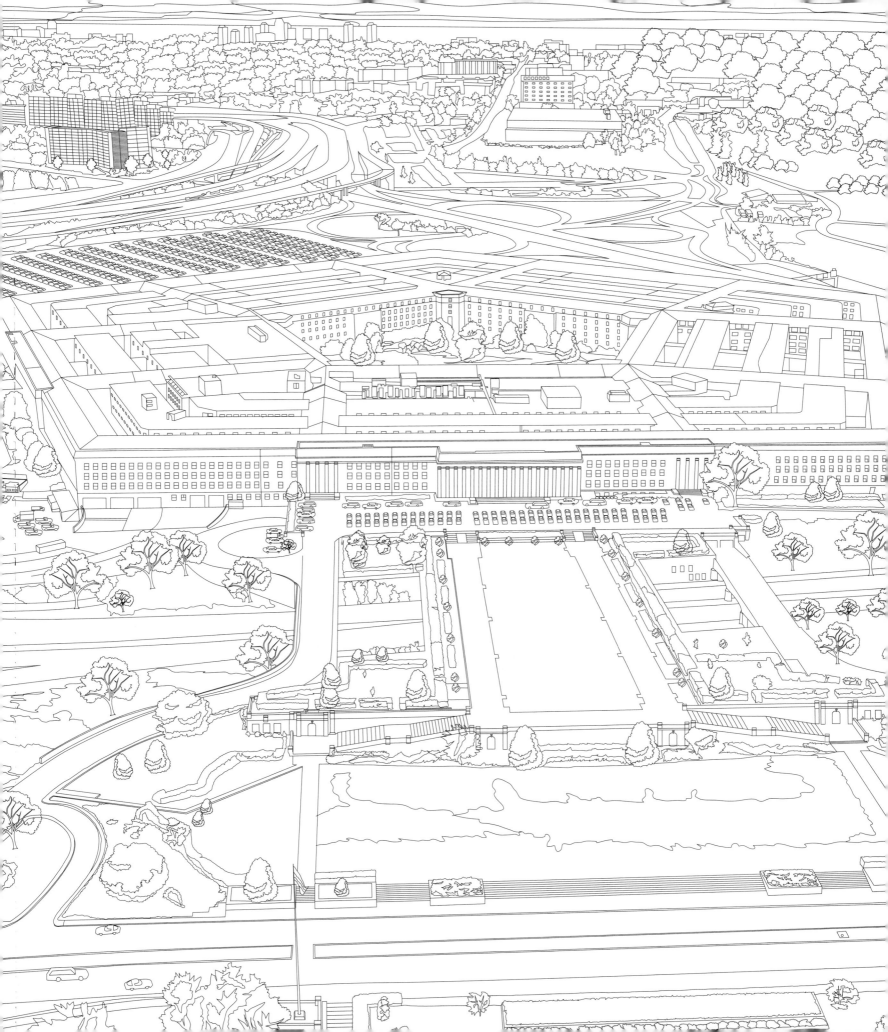

CIVIL WAR BATTLEFIELD

The Civil War was one of this nation's defining moments, a struggle that preserved a union that was less than a century old at the time. It was hard fought: the loss of life was just slightly less than the total losses from every other war in which the United States has fought. Today, the Civil War Trust works to preserve the battlefields where the principle of freedom was upheld.

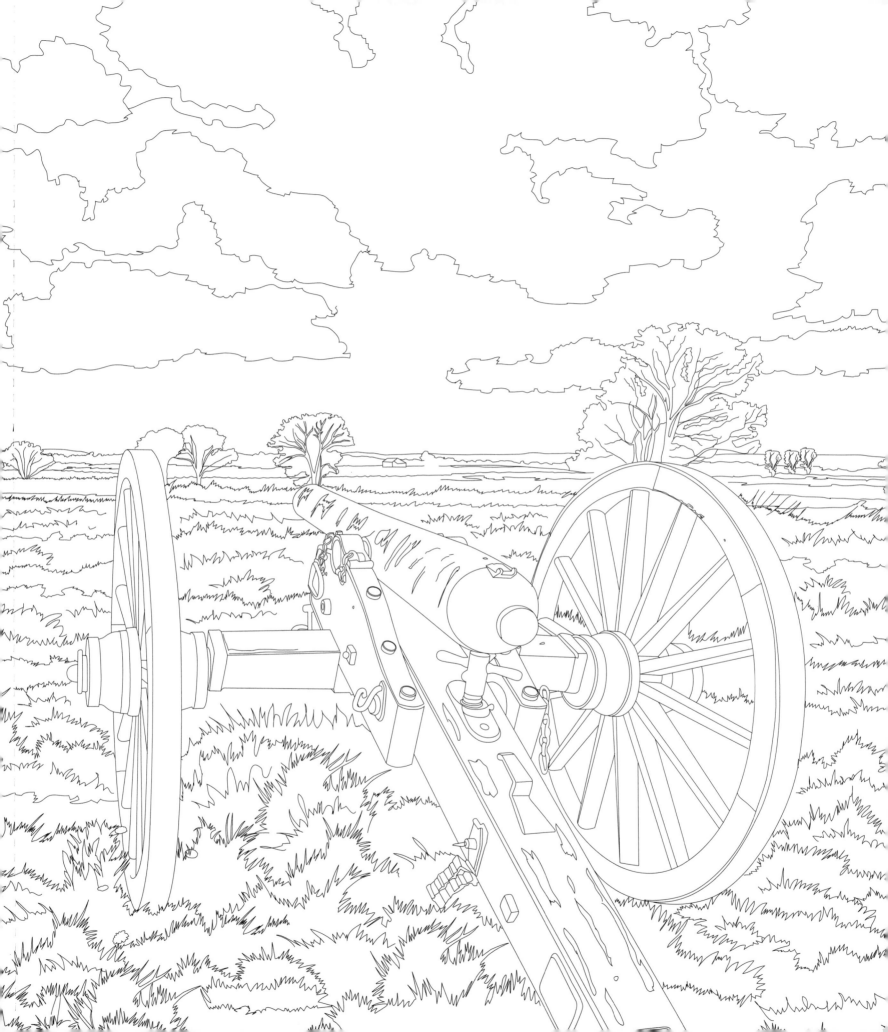

COWBOY IN TEXAS

The iconic cowboy has its roots in Texas. After the Civil War, the exhausted northern states were hungry, and a single steer would fetch the then-astonishing price of $40. And so the great cattle drives began. Soon, the cowboys developed a uniform: a wide-brimmed hat for protection from the sun, boots with heels to help them stay on their horses, and chaps for some protection against the mesquite thorn.

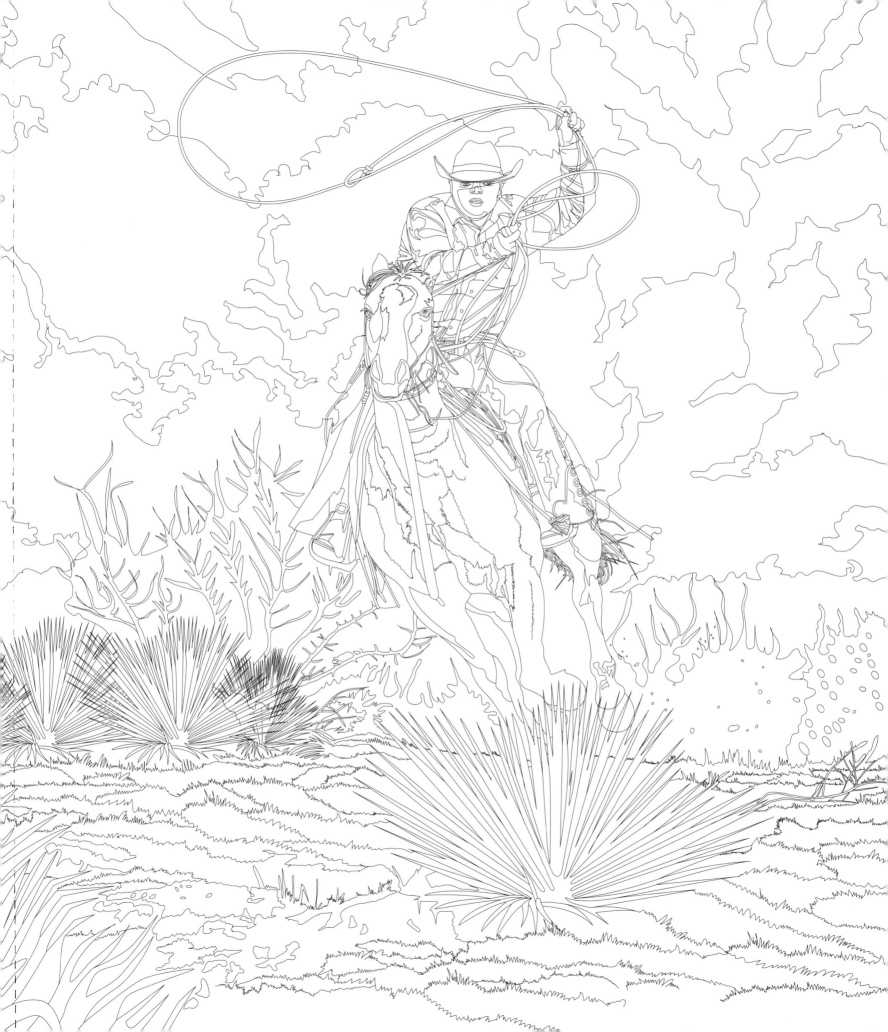

WONDER WHEEL,
CONEY ISLAND, NEW YORK

It's 150 feet tall and it's been standing since 1920—and for almost two decades the Wonder Wheel was the tallest attraction on Coney Island. It lost that title in 1939 to the Parachute Jump, a ride that stopped operating in 1964. The Wonder Wheel just keeps turning to this day. Only the New York City blackout of 1977 has ever managed to bring it to a halt.

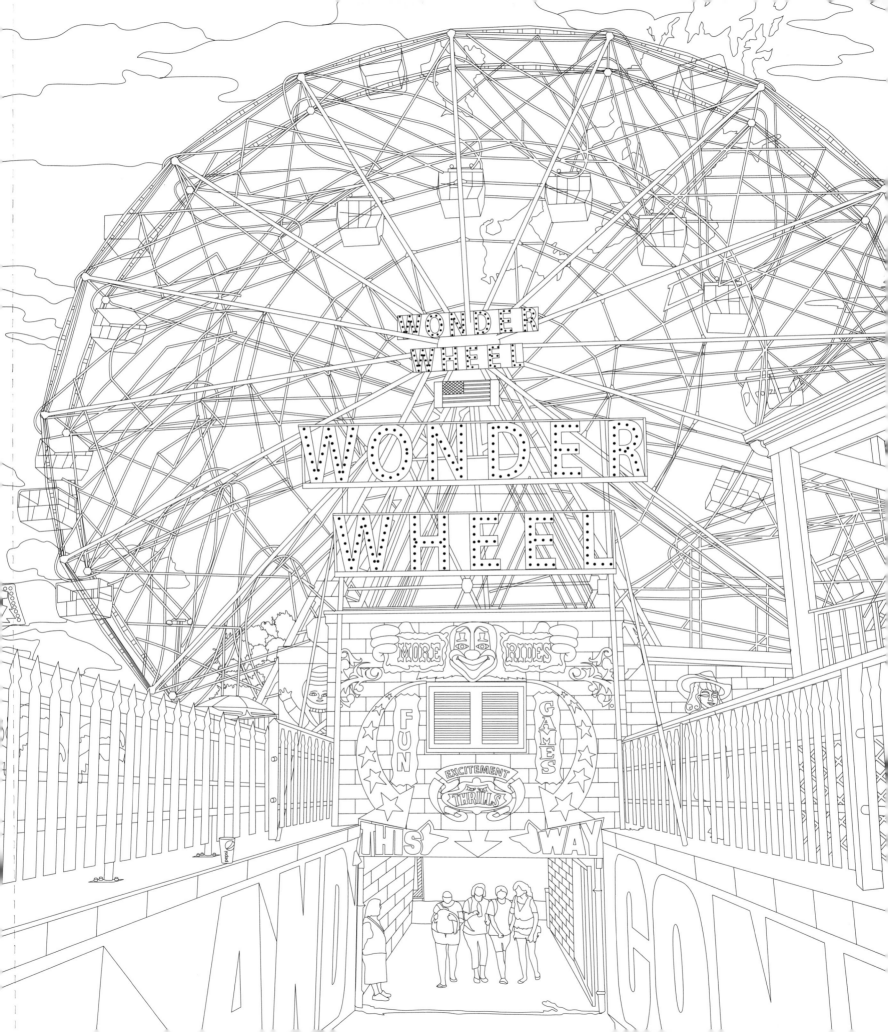

OSCAR MAYER WIENERMOBILE

It's a hot dog 27 feet long, driven by a turbocharged engine. The Wienermobile has been on the road since 1936, and since then, it's been forced off the road only by gas rationing or when the chassis hasn't been able to bear the weight of the Oscar Mayer Wiener. Drivers, known as "hotdoggers," are all recent college graduates; they hold the job for exactly one year, starting June 1.

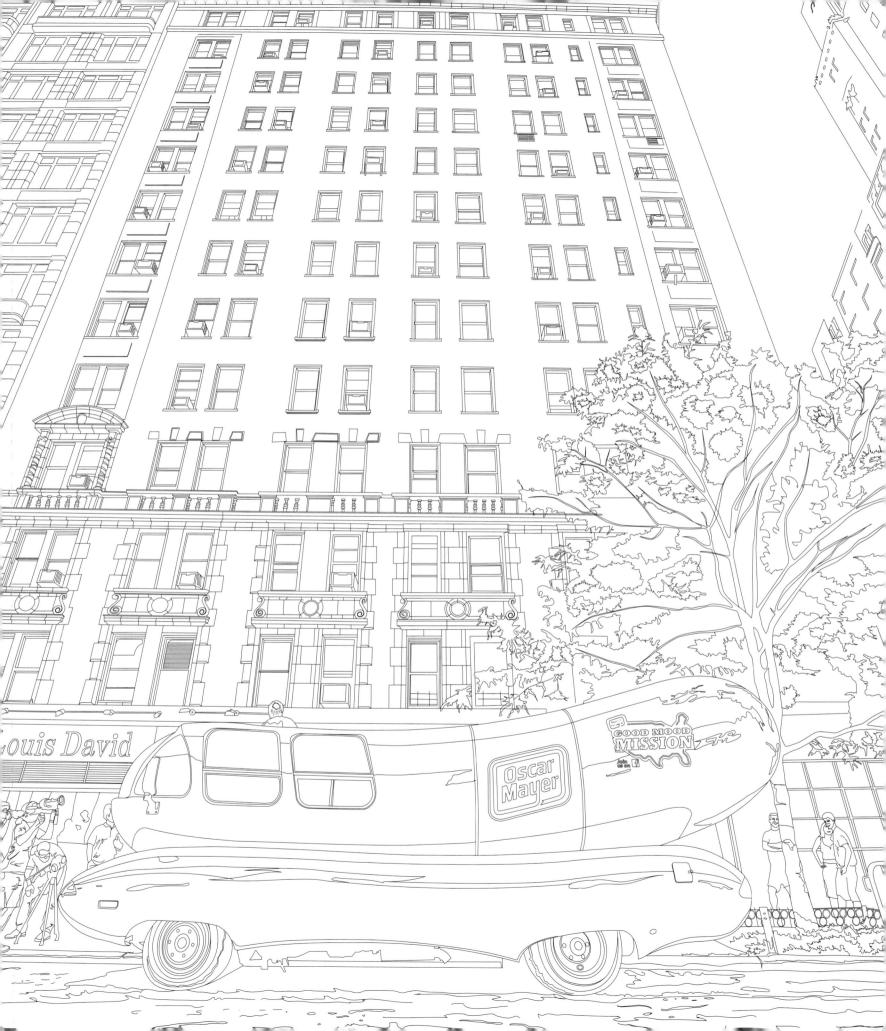

CHICAGO, ILLINOIS

The Great Chicago Fire of 1871 destroyed more than three square miles of the city—and launched the biggest building boom in U.S. history. The result was an innovation that changed the world. The Home Insurance Building, completed in 1885, was the world's first skyscraper. Even today Chicago is a city with a skyline that includes some of the world's tallest buildings.

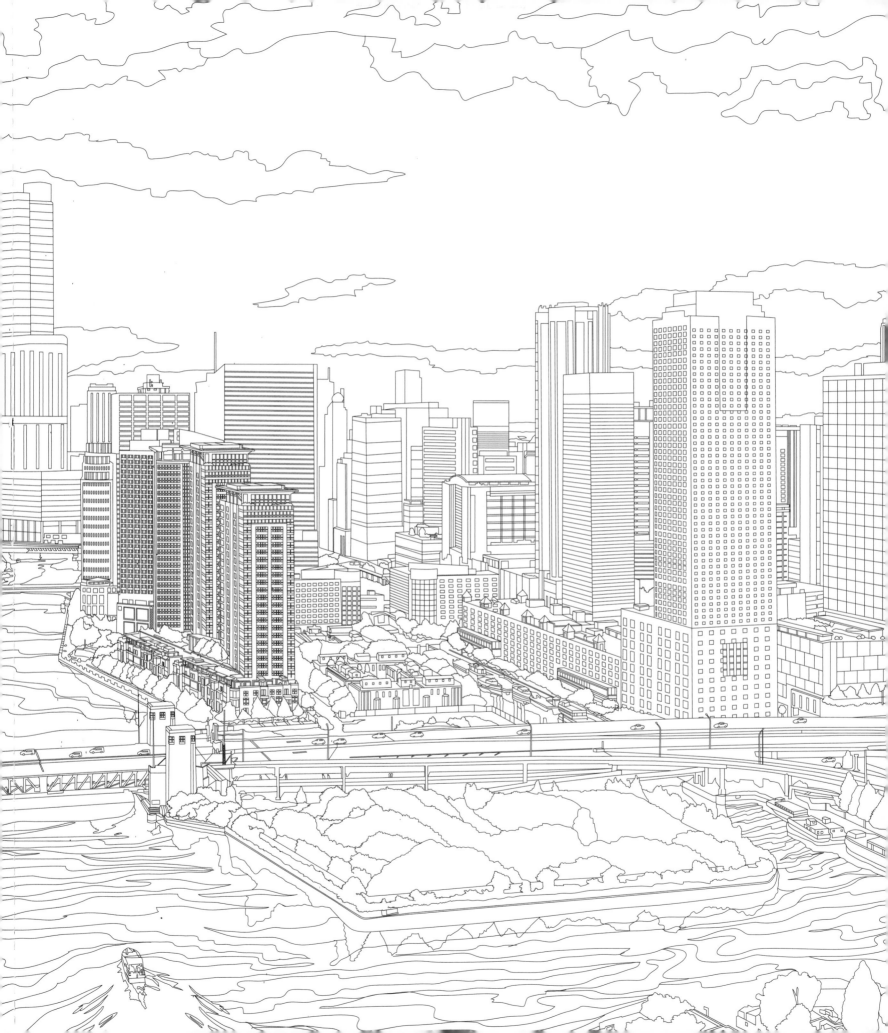

STATUE OF LIBERTY AND BLUE ANGELS, NEW YORK CITY

Formed in 1946, the Blue Angels are the U.S. Navy's flight demonstration squadron. The team is made up of 16 volunteers from the Navy and Marine Corps, and they typically serve with the Blue Angels for two years. The Blue Angels perform at more than 70 shows across the country each year.

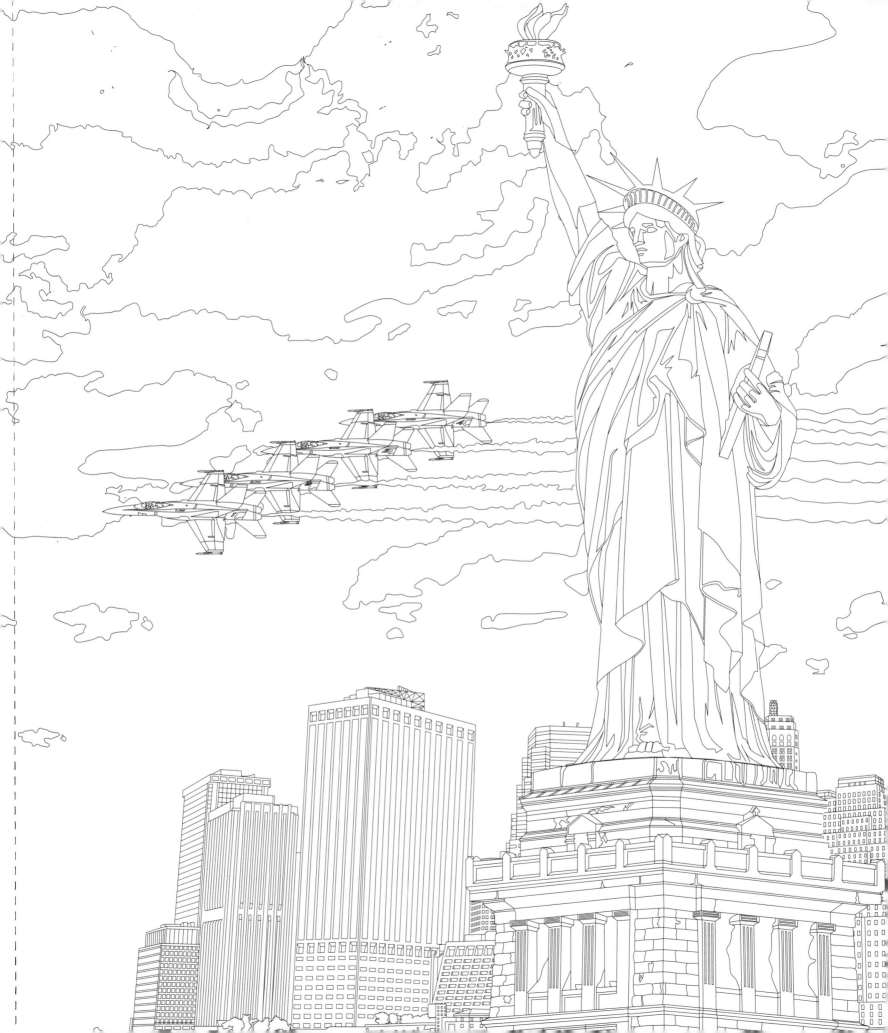

NEW ENGLAND CHURCH

So famous now are the churches of New England that it's surprising to learn that many were not originally white. It was the Greek Revival movement that introduced the color, which was meant to echo the marble temples and sculptures of ancient Greece. In the newly created United States, the new fashion was an expression of national pride—in part because the style was thought to be free of British influence.

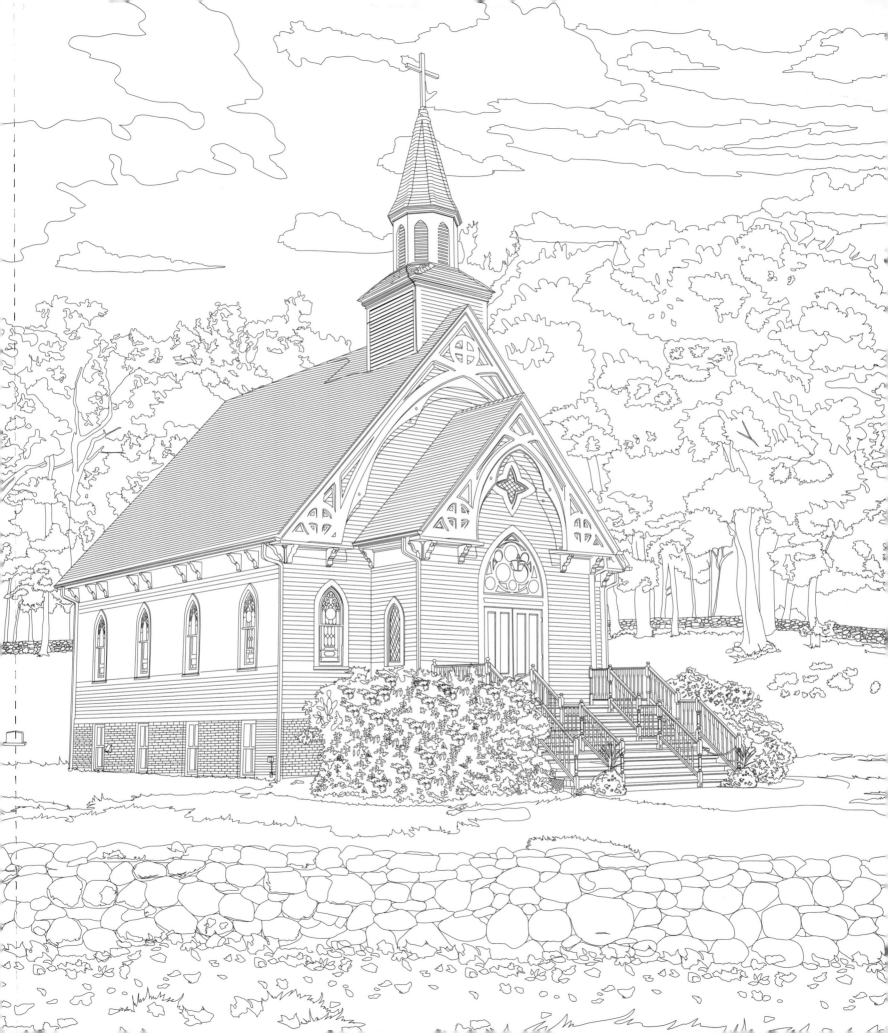

BEALE STREET, MEMPHIS, TENNESSEE

No Beale Street, no blues music—it really is that simple. In the Civil War, Memphis fell to the Union, and the newly free were quick to settle here and open businesses. Traveling musicians soon followed. The spirituals from the cotton fields met the sound of the honky-tonks—and the genre has continued to evolve over the past century.

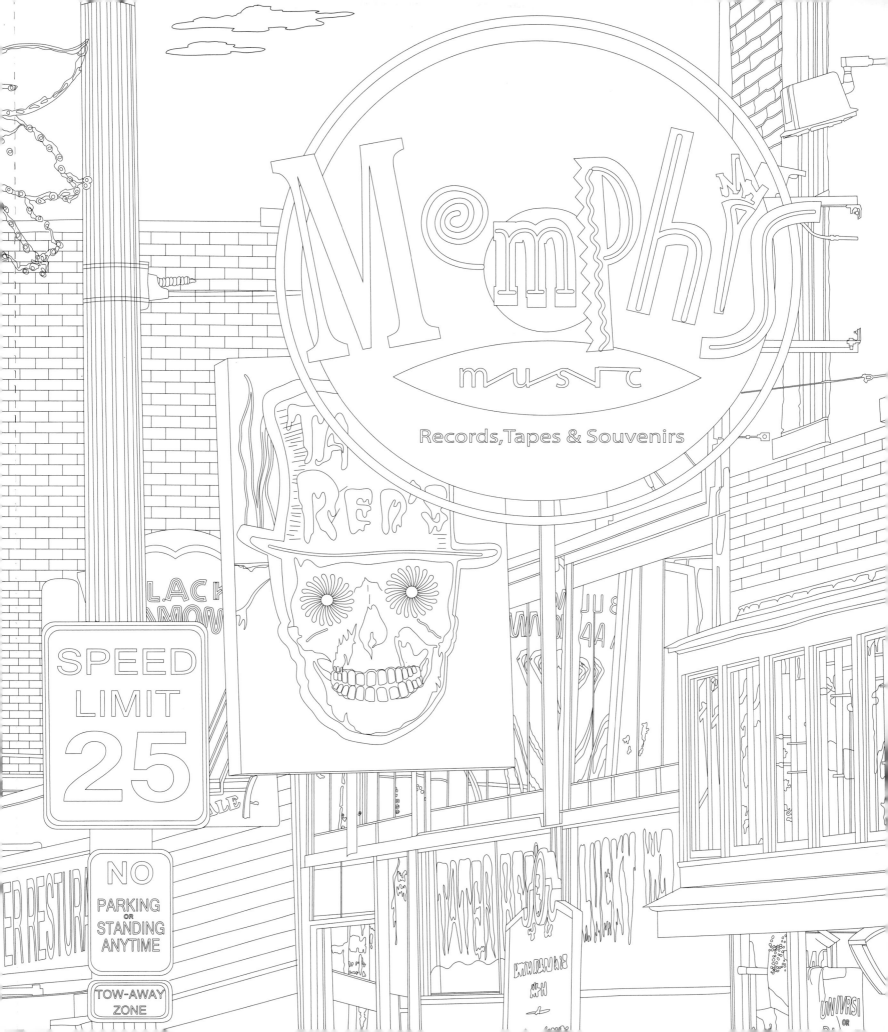

FORD MODEL T

This is the car that changed the world. Built on a production line, it was an automobile that the middle class could afford. The first sold for $825 in 1909. By the end of production in 1927, the price had dropped to $360 and 16.5 million had been produced. That's a number that ranks it as one of the best-selling cars of all time.

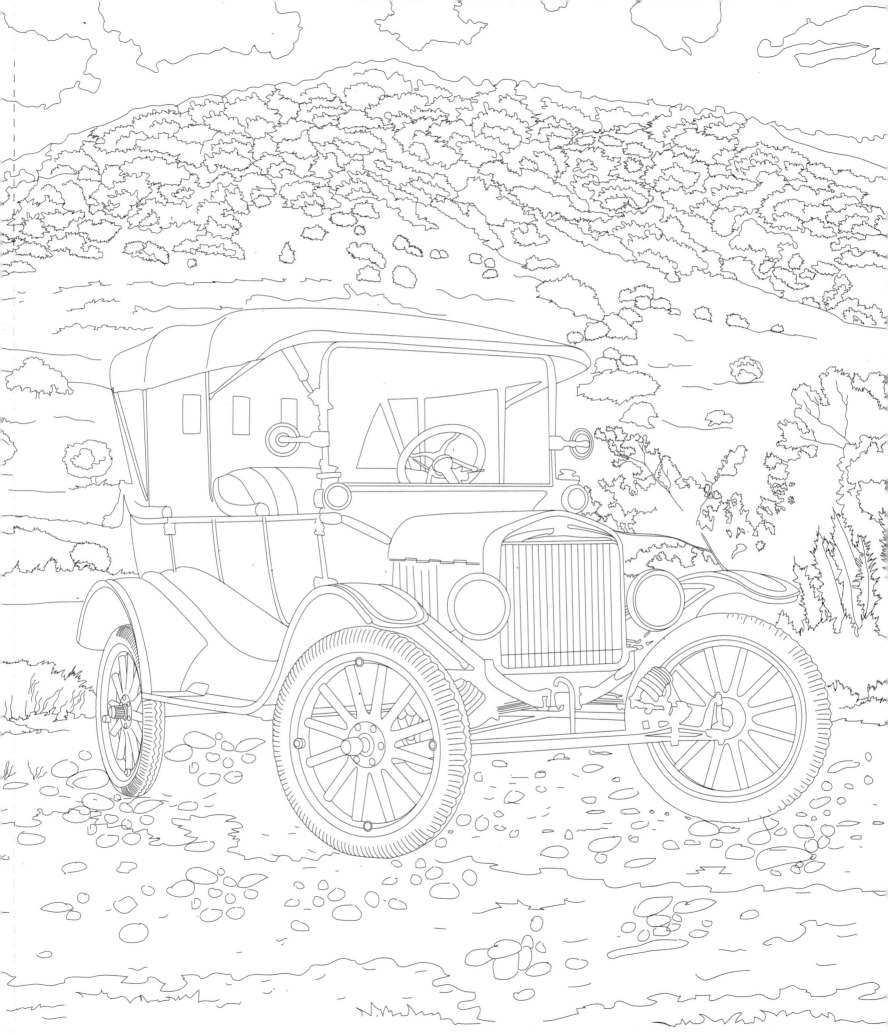

TOMB OF THE UNKNOWNS, ARLINGTON, VIRGINIA

The Tomb of the Unknowns honors those who have given their lives—and in so doing have lost their identity. The first soldier "known but to God" was brought to Arlington from France, where he fell during World War I. Now there is an Unknown soldier from World War II and the Korean War. The soldier from Vietnam was eventually identified, and today the memorial honors those who are missing from that conflict.

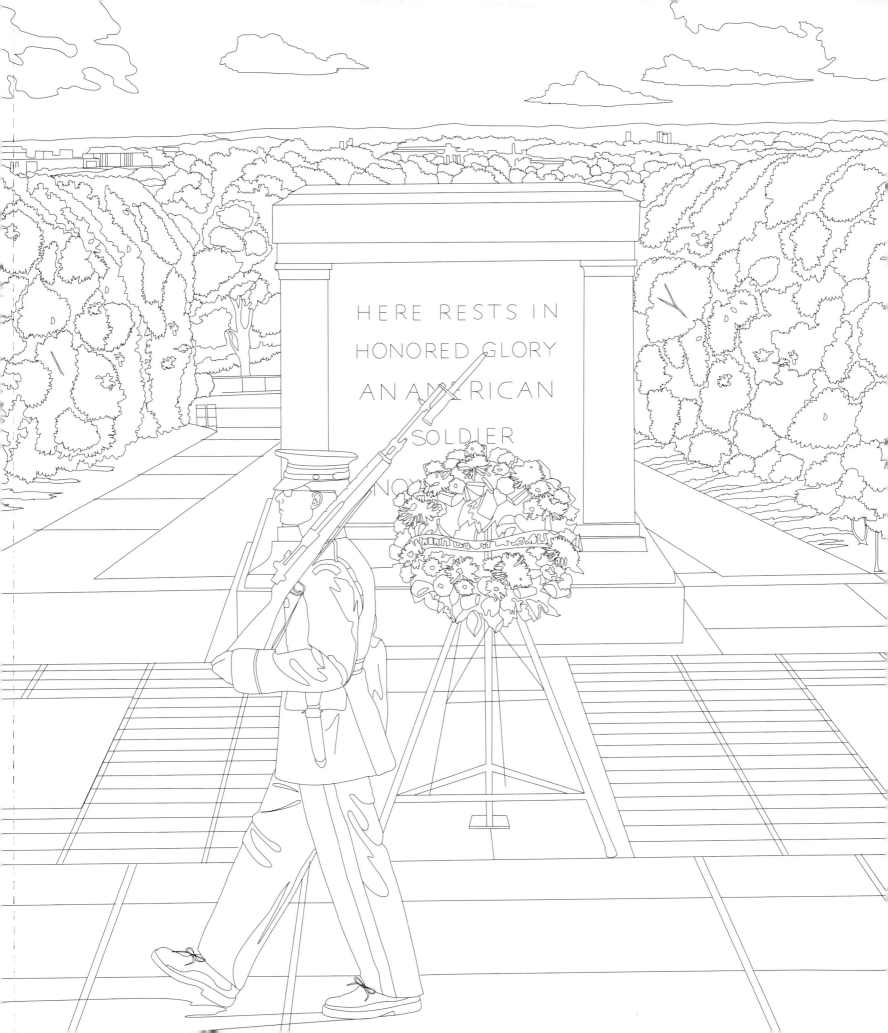

BEVERLY HILLS, CALIFORNIA

Think of Beverly Hills, and chances are you'll think of palm trees—tall, thin trees on either side of a street. Curiously, these trees are not native to the area, and many were imported from desert regions in the southwestern United States and Mexico. Many of these palms were planted in the 1930s as part of a scheme to get the unemployed back to work.

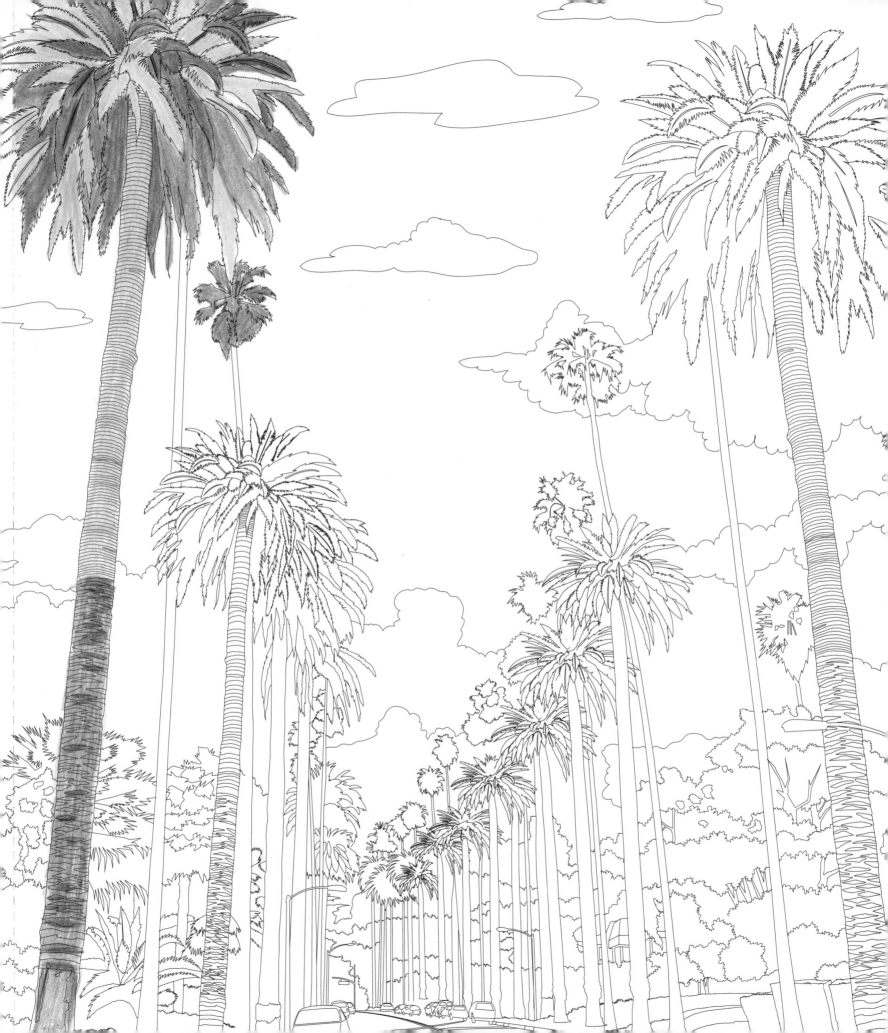

ONE WORLD TRADE CENTER, NEW YORK CITY

The tip of One World Trade Center's spire reaches exactly 1,776 feet in height. That's a deliberate reference to the year the Declaration of Independence was signed to create the United States, and is also a symbolic rebuke to those who would attack the nation. Exactly ten years after the September 11, 2001, attacks, and while One World Trade Center was still under construction, the building was illuminated with the colors of the American flag.

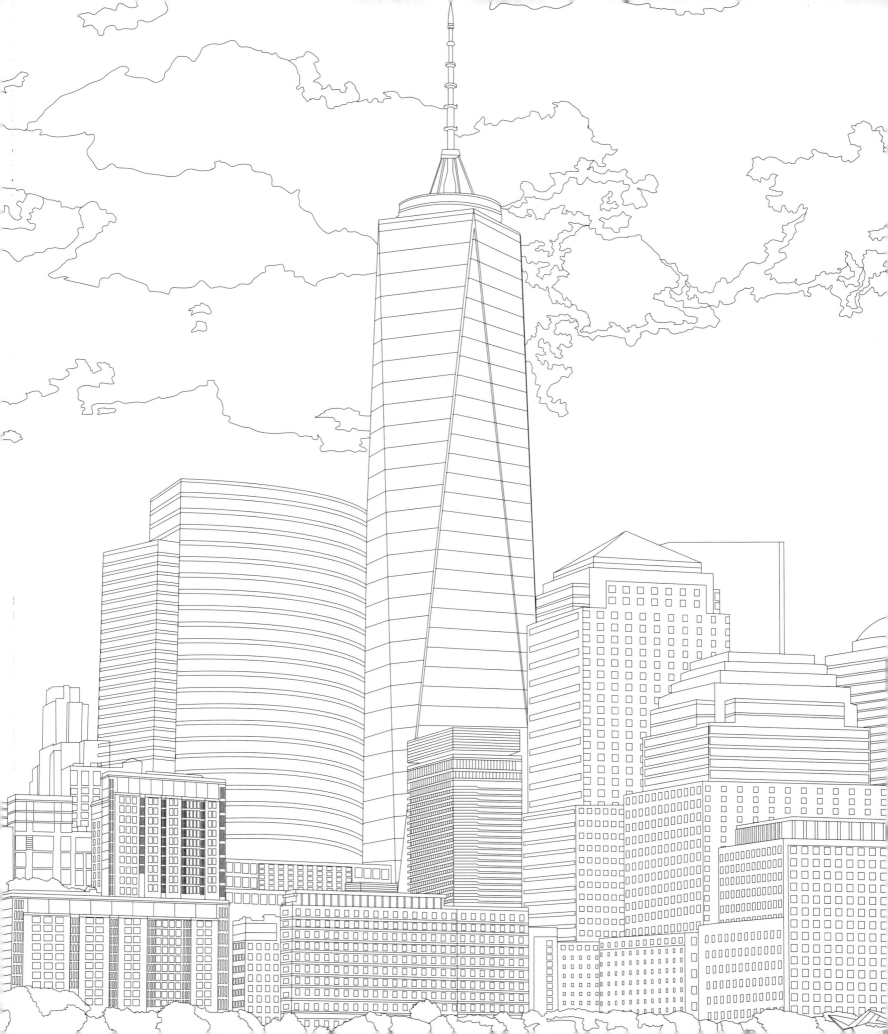

Portable Press
An imprint of Printers Row Publishing Group
10350 Barnes Canyon Road, Suite 100, San Diego, CA 92121
www.portablepress.com

Copyright © 2016 Carlton Books Limited

All rights reserved. No part of this publication may be reproduced, distributed, or transmitted in any form or by any means, including photocopying, recording, or other electronic or mechanical methods, without the prior written permission of the publisher, except in the case of brief quotations embodied in critical reviews and certain other noncommercial uses permitted by copyright law.

Printers Row Publishing Group is a division of Readerlink Distribution Services, LLC. The Portable Press name and logo are trademarks of Readerlink Distribution Services, LLC.

All notations of errors or omissions should be addressed to Portable Press, Editorial Department, at the above address. All other correspondence (author inquiries, permissions) concerning the content of this book should be addressed to Carlton Books Ltd, 20 Mortimer Street, London W1T 3JW
www.carltonbooks.co.uk

Portable Press
Publisher: Peter Norton
Publishing Team: Gordon Javna, JoAnn Padgett, Melinda Allman, Jay Newman, Trina Janssen, Dan Mansfield, J. Carroll, Aaron Guzman

ISBN: 978-1-62686-755-0

Printed in China

20 19 18 17 16 1 2 3 4 5

The publishers would like to thank the following sources for their kind permission to reproduce the pictures in this book.
3. f11photo/Shutterstock.com, 5. P.Burghardt/Shutterstock.com, 7. Julie Thurston Photography/Getty Images, 9. Andy Lyons/ Getty Images, 11. Joseph Sohm/Shutterstock.com, 13. Garrett Nantz/Shutterstock.com, 15. Ruigsantos/Shutterstock.com, 17. Kirk Geisler/Shutterstock.com, 19. Fotog/Getty Images, 21. CirclesPS/Shutterstock.com, 23. Mary Terribery /Shutterstock.com, 25. Scott Cornell/Shutterstock.com, 27. Stuart Franklin/Getty Images, 29. Nolanberg11/Shutterstock.com, 31. Gail Shumway/Getty Images, 33. Tracy Whiteside/Shutterstock.com, 35. Beketoff Photography/Shutterstock.com, 37. Bikeriderlondon/Shutterstock.com, 39. Jeff Foott/Getty Images, 41. Kzenon/Shutterstock.com, 43. Jorg Hackemann/Shutterstock.com, 45. Shu-Hung Liu/Shutterstock.com, 47. Gleb Tarro/Shutterstock.com, 49. PhotoStock10/Shutterstock.com, 51. Petar Djordjevic/Shutterstock.com, 53. Graham Mulrooney/ Alamy Stock Photo, 55. Galyna Andrushko/Shutterstock.com, 57. David Wall/Alamy Stock Photo, 59. Jim Pruitt/Shutterstock. com, 61. Brandon Seidel/Shutterstock.com, 63. Shestock/Getty Images, 65. Peter Zachar/Shutterstock.com, 67. Jerry Markland/ Getty Images, 69. Leonard Zhukovsky/Shutterstock.com, 71. Peter Gridley/Getty Images, 73. Jorge Moro/Shutterstock.com, 75. T.Photography/Shutterstock.com, 77. Pio3/Shutterstock.com, 79. John Lamparski/WireImage/Getty Images, 81. marchello74/ Shutterstock.com, 83. NaughtyNut/Shutterstock.com (Statue of Liberty), John Steel/Shutterstock.com (Blue Angels), Joshua Haviv/ Shutterstock.com (Skyscrapers), 85. Erika Cross/Shutterstock.com, 87. Natalia Bratslavsky/Shutterstock.com, 89. Car Culture/ Shutterstock.com, 91. Anton_Ivanov/Shutterstock.com, 93. Andrew Zarivny/Shutterstock.com, 95. Barry Singleton/Shutterstock.com, 97. Erika Cross/Shutterstock.com

Every effort has been made to acknowledge correctly and contact the source and/or copyright holder of each picture, and Carlton Books Limited apologizes for any unintentional errors or omissions, which will be corrected in future editions.